SOFTBOX LIGHTING TECHNIQUES

For Professional Photographers

STEPHEN A. DANTZIG

AMHERST MEDIA, INC. ■ BUFFALO, NY

Photo by Harry Lang.

Stephen Dantzig is a nationally renowned lighting expert and author of *Lighting Techniques for Fashion and Glamour Photography* (2005) and *Master Lighting Techniques for Outdoor and Location Digital Portrait Photography* (2006), both from Amherst Media. He has written more than thirty articles and lessons on photographic lighting and ethics. He is a frequent contributor to *Rangefinder* magazine, and his lessons have appeared in *Professional Photographer Magazine, PC Photo Magazine, Studio Photography & Design*, ProPhoto West, ShootSmarter.com, and the Photoflex Web Photo School. Stephen is a contributor/forum moderator at ProPhotoResource.com. His work has appeared on more than twenty magazine covers including local, regional, and national markets. Some of his published works have appeared in *Portrait Photographer's Handbook, Group Portrait Photography Handbook, The Best of Portraiture*, and *The Best of Photographic Lighting* (all from Amherst Media). He has also been published in *This Week Magazine* (Hawaii), *Pleasant Hawaii Magazine, Doll Reader, Metropolitan Home, Studio City Lifestyles Magazine, Santa Clarita Valley Living*, and the *Los Angeles Times*. Stephen is a twenty-one time Award of Merit recipient from the Professional Photographers of Los Angeles County and has received two Awards of Merit from the Professional Photographers of Hawaii. His specialties include fashion, beauty, and corporate photography. Stephen also holds a Doctor of Psychology degree from the Rutgers University Graduate School of Applied and Professional Psychology. He now works, teaches, and resides in Honolulu, Hawaii.

Published by:
Amherst Media, Inc.
P.O. Box 586
Buffalo, N.Y. 14226
Fax: 716-874-4508
www.AmherstMedia.com

Publisher: Craig Alesse
Senior Editor/Production Manager: Michelle Perkins
Assistant Editor: Barbara A. Lynch-Johnt

ISBN-13: 978-1-58428-202-0
Library of Congress Control Number: 2006937283

Printed in Korea.
10 9 8 7 6 5 4 3 2 1

CONTENTS

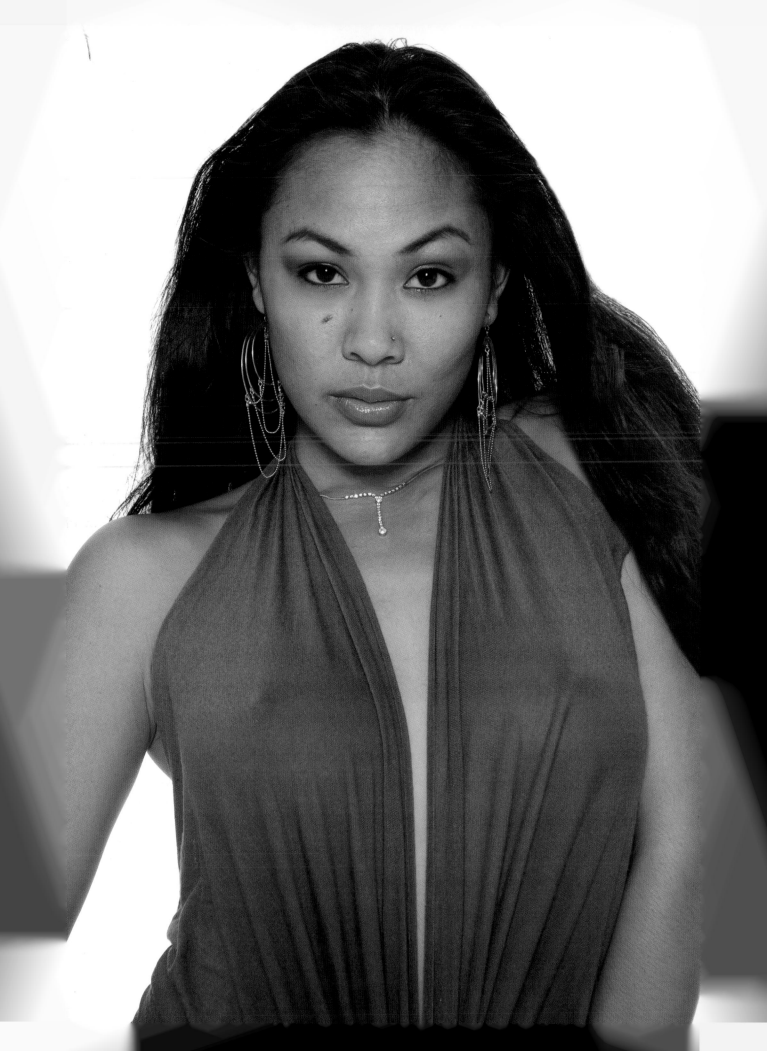

ACKNOWLEDGMENTS

This project would not have come to fruition without the help and encouragement of many people. As always, I apologize in advance to those I forget to mention. First, I give my gratitude to my good friend Bill Higgins, whose early support and unorthodox methods of teaching me photography—or rather forcing me to teach myself about photography—are with me on every shoot. Al Garcia and I have grown together as professionals and as friends for over twenty years. His influence is hidden behind each of the images in this book as well.

I was doing some writing for the Photoflex Web Photo School when Bill Hurter gave me the opportunity to write for *Rangefinder* magazine. His influence, guidance, and friendship have meant—and mean—more to me than I can express here. Also, Will Crockett, by his support and friendship, continues to be a major player in my development as a photographer.

There was a lot of work that went into each image in this book. I did not—and could not—do it alone. The people behind the scenes have a great deal to do with how each shoot turned out. They are the ones who carry all the gear, set up and tear down each set, put up with my never ending metering—and adjusting the lights ever so slightly—again and again until it is just right. They also change media cards when we fill one and generally help to keep the shoot moving in an upbeat and productive manner. I am proud to say that each of the assistants listed here are also my friends: Claude, Domi, Ed, Glenn, JB, John, Josh, Kat, Nelson, Marshall, Max, Mike, Parker, and Paul. Thanks also to my buddy Stan for the help in my studio, the occasional use of his studio, and many technical and philosophical discussions!

This book once again features the wonderful work of my best friend. Terry Walker designed the icons for me to build the diagrams that illustrate many of the images. I don't know where I'd be without you, pal! (*Note:* Some of the diagrams are built from bottom up and some are top down—it depended on the

Facing page—Softboxes are useful tools for any type of photography. Here a 30x40-inch softbox was used in conjunction with a beauty dish to create a high-fashion image for Riesey. The softbox was actually a fill light for this shot. The beauty dish is a large parabolic reflector that fits over a strobe to produce a higher contrast look than you would get with a softbox—notice the bright highlights in Riesey's hair.

best way for me to show the angle of the lights used. The perspective of each diagram is correct from the camera angle.)

I have had the privilege to work with some of the nicest and most beautiful women in the world, and some of the most talented gentlemen around. Many many mahalos (thanks) go out to the people whom I photographed for this book. I count many of these people among my friends as well. They are: Aiko, Ana, Angella, Anna, Apryle, Ashley, Audrey, Bella, Brooke, Callie, Christine, Cy Cy W., Debbie, Diane, Gene, Heatherlyn, Jenny K., Jenny W., Kathryn, Keaolani, Keoki, Lauren, Mapuana, Marie, Marissa, Michele, Michelle, Midori, Monica, Naomye, Paul, Racquel, Riesey, Ruthchelle, Sanna, Sheleen, Stephanie, Tara, Teresa, and Tishanna. Most of the ladies did their own hair and makeup, but Ashley and Teresa helped with hair and makeup duties on other shoots too. Peter Jones, Elain Saunders, and Roshar also provided hair and makeup services for some of the shoots.

I cannot go without mentioning my family. Kathryn and Susan are my sisters by chance, but we are friends by choice. The amount of love and support that they have shown me through the years is beyond words. This of course extends to Jim and my nieces and nephew and to Steve. A tip of my hat to Ken and Carol and of course the other Ken (no, you cannot ride my bicycle—ever again!) for the never ending support (and laughs)!

So, this book was an exercise in turning a challenge into a success. I hope that I have done that with the help of those listed here. However, my assistants didn't really get the kudos that they have earned: you see, this is not mentioned in my biography, but I need more help than most photographers because I have cerebral palsy and use two canes to get around. The people listed above literally help me to face the physical challenges of each photo shoot. However, there are two people who have spent my entire life teaching me that no challenge is insurmountable. My parents, Margaret and Albert, are without a doubt the reason why I am as successful as I am today. There have been many trips and falls over the years (literally and figuratively), and each time, failure and hurt were turned into an opportunity to pick myself up off the floor, dust myself off, and move on to the next challenge. This has been a tough year for us: we lost our father in December of 2005. It is with immense pride that I dedicate this book to the memory of my father. See you in Hana, Pop.

Many many mahalos (thanks) go out to the people whom I photographed for this book.

FOREWORD

I have had the pleasure and privilege of knowing Steve, and counting him among my friends, for about four years now. We've collaborated on projects and brainstormed over a couple pints on several occasions. As a photographer, and as a person, he has a gentle and genuine caring way about him. He is very easy to talk to and has some brilliant insights, and I think all this is reflected in his writing style.

As a professional photographer, a graduate of New York Institute of Photography, and one who has been plying my trade for over thirty years, I have a pretty thorough working knowledge of photographic lighting. Even so, on just about every occasion where Steve and I have worked together on a shoot, he has shown me something new, or a different way to light something to get a familiar effect!

Steve loves the physics and science of lighting almost as much as putting his knowledge of it to use in lighting a beautiful swimsuit model. I, on the other hand, prefer to just play with it. I've never been a particular fan of reading books on technical stuff—maybe because the books I had to read were rather boring—but let's face it, you must understand some technical stuff if you desire to master photographic lighting.

You must understand some technical stuff if you desire to master photographic lighting.

In addition to Steve's love of photography and physics, he truly enjoys teaching and sharing his knowledge. This is the third of Steve's books I've had the honor of reading before it went to press. I have to say that these books on photographic lighting are among the most comprehensive out there. At the same time they are a joy to read and, of course, look at! The way it is presented, you almost don't notice the technical parts. It's like you're there on the shoot with him, and he's explaining everything, conversationally, as he goes.

Soak up the knowledge! It's in here. And enjoy, as I did, reading and learning, and applying techniques of photographic lighting using softboxes!

—*Stan P. Cox II*

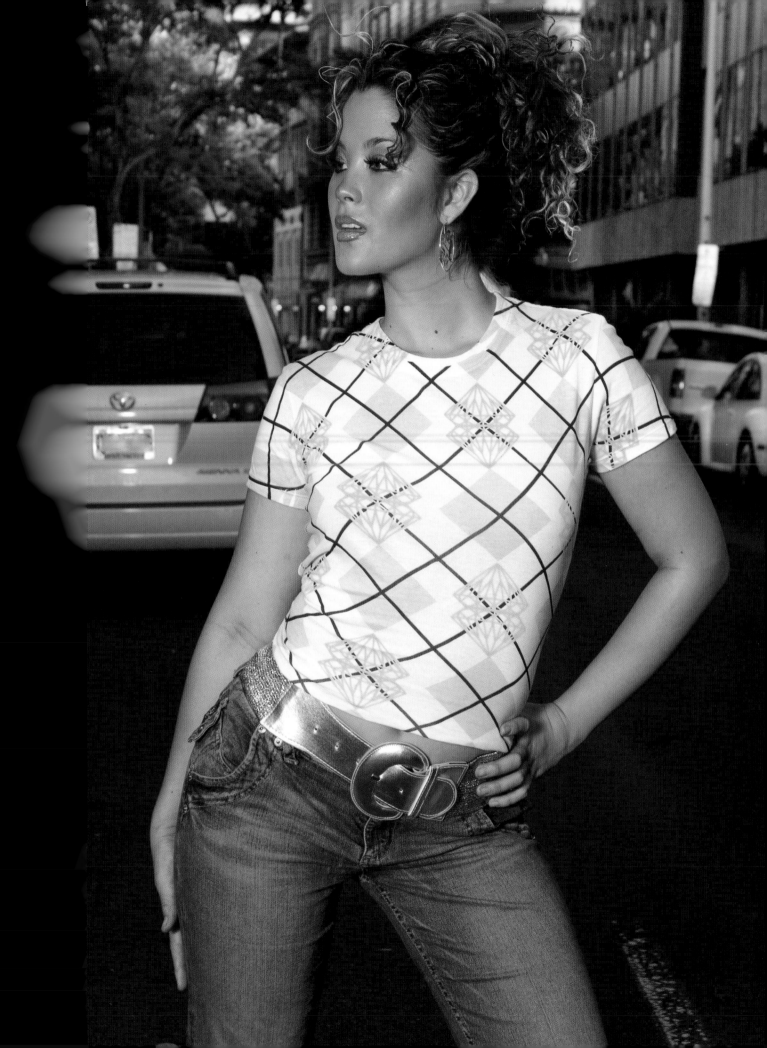

PREFACE

This book was an exciting challenge to take on. I received an e-mail from the editor of *PC Photo* magazine after my book, *Lighting Techniques for Fashion and Glamour Photography*, was released and was asked if I would write an article on the basics of using a softbox. "Sure, no problem," I replied. The *PC Photo* article ran, and I received an e-mail from Craig at Amherst Media saying that he loved the softbox article and would I develop it into a full-length book on some of the creative uses for softboxes? "Uh . . . sure, no problem," I replied. Well, the reality is that I had no idea how I was going to take a topic that filled four pages in a magazine and turn it into a book. But I dove in, and tackling it became a wonderful odyssey where I was given license to play. I had to try many new things because I had to come up with new techniques to write about. I wound up driving my assistants nuts because we would show up at the studio or on location with a truckload of gear and they would ask me what we were doing. I'd say, "I have no idea, but let's set up X (whatever toys we had available) and see what she (our model) brings!" Each shoot became a "work in progress" as we tried new and different combinations of lights. We played with lights of many different sizes and styles in the studio and on location. We used different Adobe Photoshop techniques and tricks to enhance—and in some cases make major changes to—the images. In this book, I will take you along on my odyssey to continually invent new ways of looking at and playing with light while producing professional-caliber images. You'll be introduced to some of the laws that govern light and get an idea about why digital photography can be more difficult than film photography. You'll see some of what have become my favorite tools—both on the set and in postproduction. Most importantly, I hope you will be inspired to try new and different approaches in ways that will keep the creative juices flowing and will keep you asking, "Yeah, but what if I . . . ?"

Cy Cy was photographed in downtown Honolulu. She was lit with a combination of ambient light and a strobe tucked into a Halo-type softbox. The background was manipulated using a multiple RAW conversion technique described in chapter 6.

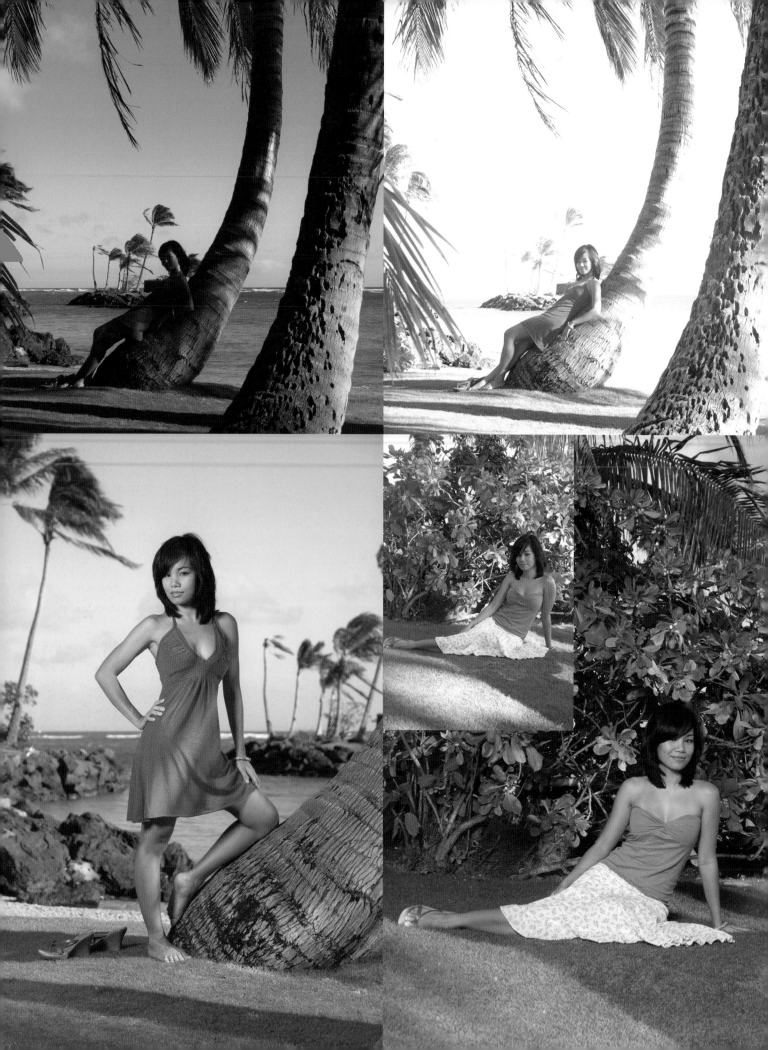

INTRODUCTION

Creating portraits, fashion shots, and beauty photographs can be a never ending source of satisfaction and fascination. Manipulating light to capture your vision in a fixed form is a blast! However, it can be a daunting task for someone who is just starting out as well as the seasoned pro. Light has many scientific properties that combine in specific ways, and changing one property will change your image. The factors involved with lighting your set will differ depending upon whether you are indoors (in a studio or corporate office, for example) or in an outdoor location. You are in full control over how your photograph looks when shooting in the studio, but you will have to deal with—and manipulate—existing light conditions when outdoors.

Digital capture has also influenced the way we need to light our sets. Digital capture results in images with more contrast, so you risk losing detail faster. Most of the images in this book were created digitally, so we will emphasize the specific challenges that digital photography presents. However, some images were created with transparency film. As we will see, there is not a great deal of difference between shooting transparency film and digital—the exposure and contrast issues are very similar with these media. However, many digital photographers have transitioned from shooting negative film and are having a tough time. We will explain why this is happening and talk about ways to ease the transition. The information presented in this book will be easily applicable to all mediums of photography, but we will emphasize working within the most difficult mediums.

While each new generation of digital technology improves the quality and ease of use, the fact remains that the most difficult medium within which to capture quality images continues to be digital capture. I know what you are thinking: "I thought digital was easy. After all, we can preview the images and then manipulate them later." Both comments are partially true. However, there is a serious misunderstanding about digital photography. While digital photography

Facing page—Outdoor lighting can be difficult. This composite of Naomye shows some of the pitfalls of outdoor lighting—and how a softbox-type light modifier fixed them. The top-left photograph was exposed for the background. The beautiful location is visible, but Naomye is hidden in the shadows. The top-right photograph was exposed for her skin tones. Now we see a beautiful young lady, but the background is grossly overexposed. We introduced a strobe in a Halo-type softbox and balanced the light in the shade with the light behind her to create the image on the bottom left. The inset photograph on the bottom right was created by softening the harsh direct sunlight with a scrim. Once again the strobe/Halo was used to raise the light values under the "man-made" shade to maintain the highlights and blue sky behind Naomye. These techniques are discussed in detail in chapter 6.

has provided immediate feedback and is accurate in many situations, the reality is that for images that go beyond snapshots, lighting for digital capture is difficult. The exposure latitude for digital capture is extremely narrow—especially when shooting in one of the JPEG modes. A narrow exposure latitude means that an image will be one with high contrast. As a result, many photographers who are transitioning from shooting negative film to digital are experiencing difficulty holding the whites and are losing the black more rapidly than before.

However, this does not mean that professional-quality images are not possible with digital capture. In contrast, the digital revolution has forced professional photographers to gain much tighter control of their lighting and exposures. Proper metering and an understanding of how different lights work at the same exposure are two of the keys to creating professional-quality images with digital capture.

So, how does someone begin this wonderful journey—especially with the difficulties presented by digital capture? How do you weed through the maze? There is a terrific tool that will give you beautiful results from the start and help you learn about the properties of light to keep you advancing in your understanding of lighting.

The "magic" tool is a softbox. Softboxes come in various shapes and sizes and work primarily by modifying what is called the "quality" of the light. Quality of light refers to how harsh your shadows are in your image. Small lights or lights that are far from your subject will create deep, dark shadows and a quick

A narrow exposure latitude means that an image will be one with high contrast.

Left—Certain brand names are mentioned in the discussion of my lighting schemes. Neither the author nor the publisher are affiliated with the manufacturers of these tools, and no one endorsement of one product over another is implied. Other manufacturers may have similar products with different names. Ask your dealer. **Facing page image and diagram below—**I arrived at the studio planning on constructing a fairly elaborate set using four or five lights. Murphy paid a visit to my studio before I arrived, and I realized that all but two of my strobes were down. There was no way to reschedule the shoot because Kathryn arrived with us! We were using a white backdrop, so one light was designated to illuminate the backdrop—leaving us with one light to play with. Fortunately, you can create many beautiful lighting effects with one light. We placed the strobe in a Photoflex large Lite-Dome to create this fun image of Kathryn. Kathryn did her own hair and makeup.

Photoflex Extra Large Litedome [about 40X60]	Scrim
Photoflex Large Litedome [about 30X40]	Sun
Westcott Halo	Clouds
Photoflex Medium Stripdome	LiteDisk Scrim
Photoflex Small Stripdome	
Umbrella	Trees
Spotlight	Camera
Mirror/Silver Reflector	

Mountains

Table

Black flag

Male Subject

Female Subject

Backdrop/Background

Facing page—One 30x40-inch softbox is large enough to create fashion images of a couple. The light is closer to Keoki, but Kathryn's face is turned into the light to minimize the effect of the falloff of light that is created by the greater distance. **Right**—One mathematical formula that can be used to determine the "ideal" placement of a rectangular light source is the Pythagorean theorem. However, you can also find the ideal spot by watching your subject's face as you slowly bring the light closer to the model. His or her face will "pop" when the light is at the ideal spot. This technique might not be as scientific, but it will work in a pinch! The mask of Teresa Bringas' face jumps out from the dark backdrop when the 30x40-inch softbox is positioned properly. Here, a large Photoflex LiteDome provides the main light for these fashions modeled by Teresa. Smaller and narrower softboxes (Strip-Domes) are good for hair and rim lights because the have more contrast than their larger counterparts, so you can keep them within the exposure latitude of digital capture while creating nice highlights.

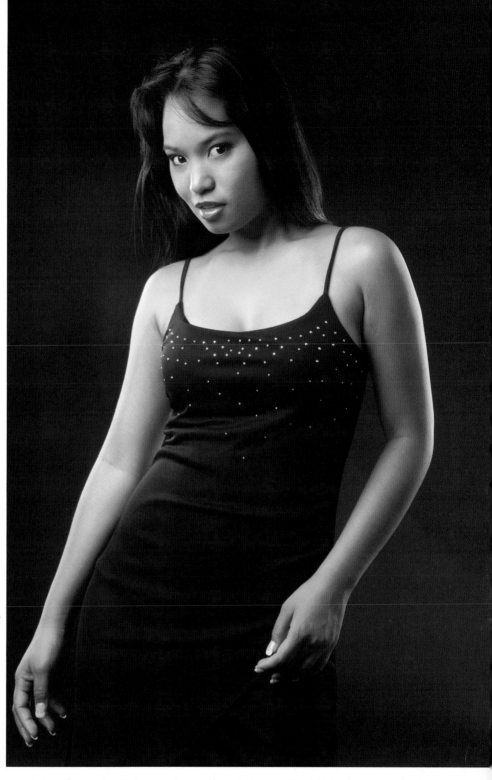

transition from the light portions of your image (highlights) to the shadows. These lights produce high-contrast images that are characteristic of a harsh quality of light. Photographs taken in direct sunlight at high noon are examples of harsh, high-contrast images. (Even though the sun is a huge light source, its extreme distance from the Earth makes it a pinpoint light that creates harsh shadows.) Similarly, unmodified strobe or floodlights will create harsh photographs in the studio because they are relatively small light sources.

There is a place in fashion photography for harsh lights—and we will explore these situations later, but generally speaking, images with a gradual transition

from highlight to shadow are more pleasing, particularly in portraiture. Larger or closer lights will produce this "soft" quality of light. Softboxes take a small direct source of light and expand it to the dimensions of the box: the bigger the softbox (at a set distance), the softer the light.

Why does one softbox create such a beautiful image? The answers lie in the design of the softbox and the techniques used to light your subject. Softboxes are designed to produce an even spread of light coming out of every part of the box. This light is also extremely soft if the softbox is relatively large (30x40 inches or larger for lighting a single person or couple). Every light will produce a "hot spot" where the light reflects off of your subject's skin. These hot spots are also called "specular highlights." Large softboxes produce wide, spread-out hot spots that are easily controlled without much chance of losing detail. Smaller light sources create sharp and highly specular hot spots that can lose detail very quickly if your exposure is not exact.

The amount and quality of light is theoretically the same at the corners of the box as in the center. This information helps us know how to position the softbox to get the most out of its design. There is no need to point the center of the box directly at the center of your subject. In fact, doing so wastes half of the softbox because half the light hits behind your subject. Instead, use a technique called "feathering" to get the most out of your softbox. Position your softbox so the inside (relative to your subject and backdrop) edge lines up with the edge of your subject's face. It may appear as though you are wasting the outer half of the softbox, but in fact you are allowing the light to wrap around your subject and fill in some of the shadows on the opposite side.

The distance at which your softbox is placed from your subject will also impact its effectiveness. Each light has an ideal distance that maximizes its size and contrast. There are mathematical formulas that can be used to determine *the* spot that optimizes the qualities of a softbox, but fortunately there is a much easier, less scientific way to do it: pull the light back a good distance from your subject. Slowly move it closer. There will be a spot where the light will suddenly "pop" off your subject's face! *That* is your ideal distance for your light!

Most softboxes can be adapted to hold strobes or "hot lights." Hot lights are lights that are always on, such as floodlights. Strobes produce a quick, instantaneous burst of light that illuminates your subject. Each light source has pros and cons. The following chart highlights some of the critical differences. We'll take a closer look later.

Many professional fashion photographers use hot lights to create their images. My personal preference is to use strobes. However, hot lights may be the way to go when starting out. The two most apparent benefits of using hot lights is the start-up cost and the ability to use your in-camera meter or even the autoexposure feature of your camera. This can be a risky move, though, because metering is a critical factor with transparency films and digital capture. Your exposure has to be accurate. One effective way to meter your set with hot lights is to simply put a gray card in the same light as your subject and bring your camera close enough so that the gray card fills the viewfinder and take a meter reading.

Softboxes take a small direct source of light and expand it to the dimensions of the box.

Another factor to consider with hot lights is the color temperature of the lights. Some floods are like household lightbulbs and some are like high-noon sunlight. You have to either choose the correct film or set the white balance on your camera according to the type of floods you have. Alternatively, you could set a custom white balance each time you shoot. (See the manual for your digital camera for details on setting a custom white balance.)

Perhaps the biggest disadvantage of using hot lights has to do with the exposure controls. You are recording a constant source of light, so you need to be concerned with your shutter speed. Most of the starter floodlights look very bright but do not really supply that much light. You might be surprised at how slow you need to shoot to keep a decent amount of your image in focus. You risk motion blur at slow shutter speeds, so your model needs to keep very still.

Strobe lights with modeling lamps, in my opinion, solve most of these concerns. Strobes illuminate your subject with a single blast of light that is many times brighter than a darkened studio. As long as you are set at your camera's sync speed or slower, your shutter speed won't matter (unless you are shooting at a really slow speed). You can freeze motion and maintain a good amount of focus with strobes. Strobes also tend to be set at color temperature resembling daylight at noon. Set your camera's white balance to the daylight setting and fire away (or you can still set a custom white balance).

The major drawback to strobes when you are starting out is metering the light output. In general, you cannot use your camera's meter to judge the exposure of your strobes. You need a flash meter, and those can be costly. There is a temporary solution to this problem. Set your softbox at various places around your set and mark the spot. Keep the output of the strobe constant, shoot one

	VISIBILITY OF EFFECT	TEMPERATURE	COLOR TEMPERATURE	METERING	EXPOSURE CONTROLS	COST
HOT LIGHTS	Lights are always on, so the effect is clear.	Lights are always on and the studio can get hot, especially if the lights are close to your model.	Varies according to the type of floods you have. Floodlights tend to be tungsten (or like household lamps), but there are "blue" floods, which resemble daylight.	Through-the-lens (TTL) reflective metering is possible.	Aperture and shutter speed is involved with determining the proper exposure.	Usually inexpensive, but floodlights burn out fast and need to be replaced on a continual basis.
STROBES	Strobes supply a quick burst of light that is not helpful when placing your light. However, most good strobes have modeling lamps, which are low powered hot lights to allow you to see the lighting scheme before shooting.	Heat is usually not an issue.	Most strobes are set to mimic daylight at noon.	Need a flash meter—usually handheld.	Only the aperture is of concern in a darkened studio. An intricate combination of ambient/strobe exposures and an understanding of how and when to change your shutter speed and/or aperture is needed when using strobes outdoors.	Entry-level strobes can be reasonably inexpensive, but the price increases dramatically for better units.

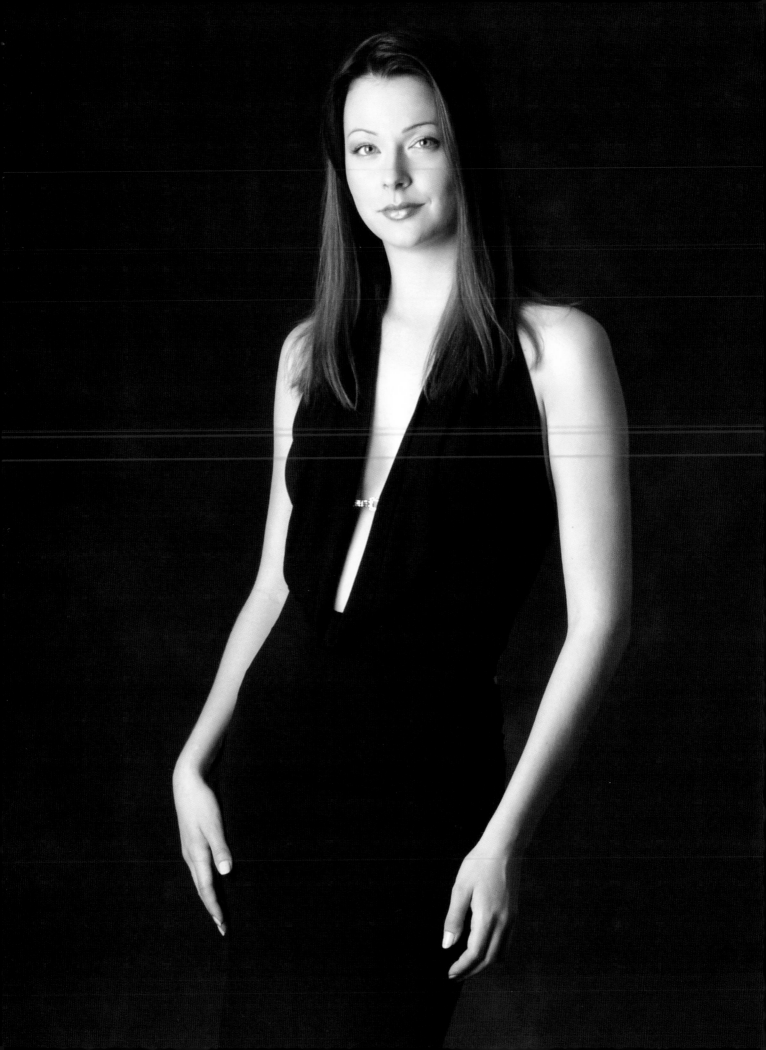

The same sized softbox was used in each of the images shown on pages 18–20. The positioning of the softbox, relationship to any additional lights on the set, and relative exposure contribute to the extremely different images created. The image of Anna (facing page) shows the softbox in isolation, creating a beautiful light ideal for low-key portraits or elegant fashion images. The image of Monica Ivey (right) shows the softbox as a main light for a beauty headshot. Strip-Domes are used as hair lights. Finally, the dramatic glamour photograph of Teresa Bringas (page 20) shows the softbox as part of an elaborate set combining many lights of different sizes and intensities.

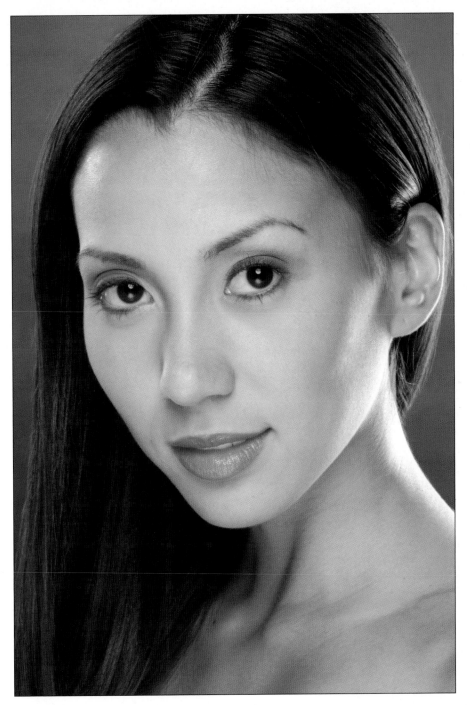

shot at each f-stop, and examine the histograms for each image. The one with the full range of tones will be your starting point. Make a note of the aperture at each marked spot. This method has some major problems, but at least you'll be shooting—and saving for a good meter!

You will quickly want to add lights to your set, and when you do, the exposure control system just described will become a nightmare. Whether you are lighting your set with one main light (a main light provides most of the illumination for your subject and determines the direction of the light in your image) or many lights, the best way to determine your exposure is by using a high-quality light meter—*not* a piece of tape on the floor, not a Polaroid, and definitely not the LCD screen on your digital camera.

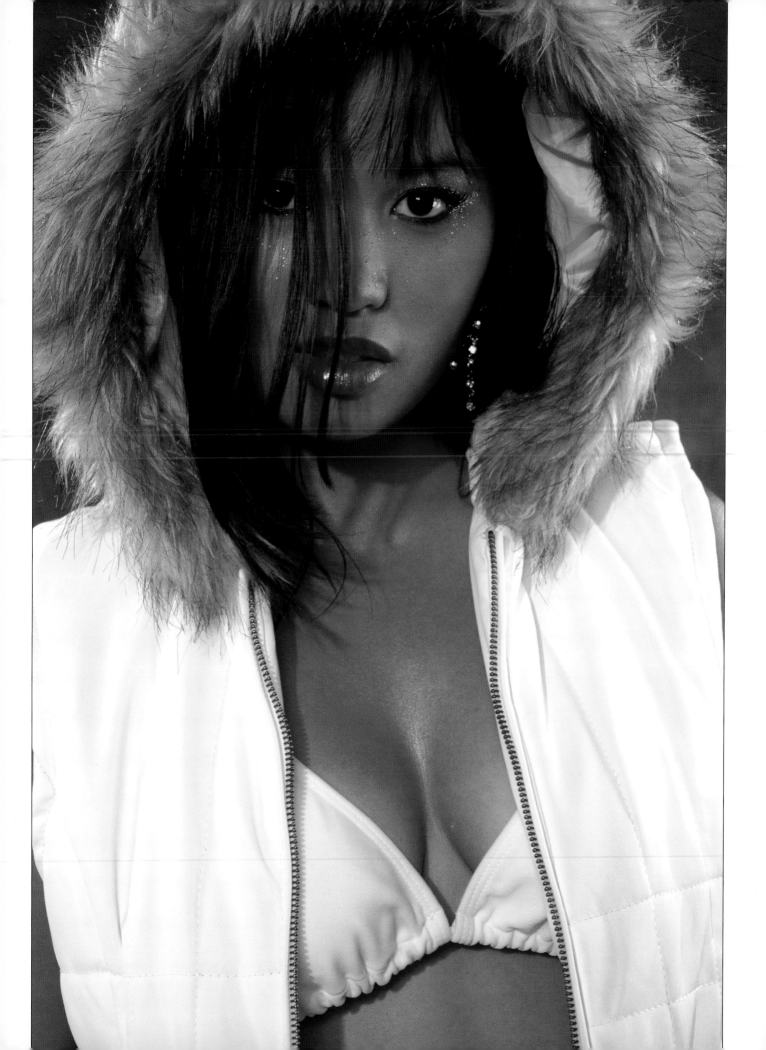

Whether you are using hot lights or strobes, you will be open to a multitude of creative options once you master the use of a softbox. The softbox is, in fact, one of the most versatile tools in the professional photographer's bag of tricks. It can be used in isolation to create a beautiful portrait or a dramatic fashion image. It is also useful as a main light in conjunction with hair lights for a beauty headshot or even as a co-main or fill light in elaborate lighting setups.

It doesn't matter if you are using hot lights in a studio, strobes in a corporate office, or direct sunlight on a beach, there will come a time when you will have to modify the light to create the look you desire. There are many laws of physics that define how light works and what you can do with it. I have written two books detailing the technical aspects of light and lighting (*Lighting Techniques for Fashion and Glamour Photography* and *Master Lighting Techniques for Outdoor and Location Digital Portrait Photography*—both from Amherst Media), so this book will look at the creative uses for the softbox rather than delving deeply into the science that governs light. However, there are some basic laws that we need to look at as they relate to using softboxes. We'll start with these basics and then go have some fun!

There are many laws of physics that define how light works and what you can do with it.

THE CHARACTERISTICS OF LIGHT

*L*ight is governed by many laws of physics. These laws can be manipulated in ways that produce predictable results. Anyone can grab that perfect shot; however, understanding the laws and manipulating them accordingly will allow you to consistently *create* the perfect shot.

I promised in the introduction that I would try not to get too "techie," but there *are* some technical issues that we need to address up front. I have chosen to look at four technical aspects of light that will influence each photograph you create and are particularly pertinent to the creative uses for a softbox. These aspects, presented in an arbitrary order, are: (1) quantity of light and how to measure it, (2) quality of light and how to manipulate it, (3) color temperature and how to play with it, and (4) the additive nature of light (or how do I add lights to my scene and still control how the image looks?).

As the exposure latitude becomes narrower, the images have more contrast. . . .

QUANTITY OF LIGHT

Quantity of light simply refers to the amount of light that you are recording (photography is actually the process of recording light that is reflected off of your subject). Quantity of light is directly related to your exposure.

A "correct" exposure shows the full range of colors (or grays) available to the particular type of photography you are engaged in. If, for example, you are shooting black & white negative film, then you have an extremely wide range of grays between black and white that you can capture. The current state of digital photography, on the other hand, allows us to capture less than half of the tonal values available to some black & white film. As the exposure latitude becomes narrower, the images have more contrast, and the demand for exposure control become more exacting. This holds true for hot lights, sunshine, or strobes. It doesn't matter what you are using to light your subject, you need to know how to record it accurately. Every image has a "proper" exposure. How-

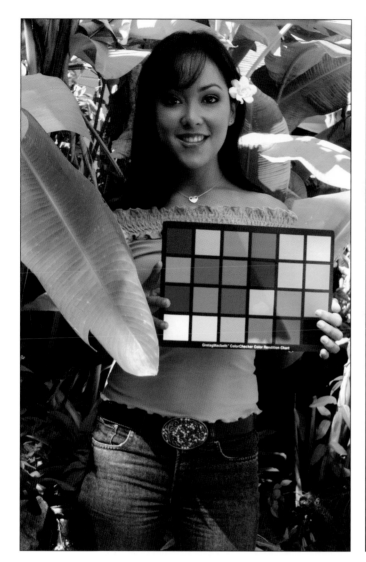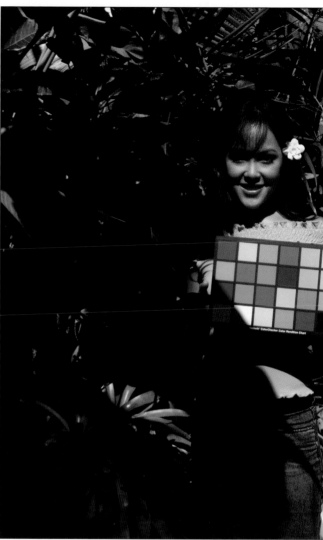

YOU decide what the most important part of your image is and meter accordingly. These two images of my friend Kathryn show the importance of critical metering. The difference between these two shots is dramatic even though she moved only about one foot from one image to the next. However, the handheld incident meter was positioned at the color card with the dome pointed at the lens of the camera. The color card is perfectly exposed in both images.

ever, a "properly" exposed image will have a "neutral" section (usually defined by the main lights), a section that is underexposed in relation to the main exposure (known as the shadows), and a section that is overexposed compared to the main exposure (known as the highlights).

In the introduction, I discussed a couple of really bad ways to determine exposure. The "tape on the floor" method worked for me during my early years, but I was shooting negative film (think "Lots of room for making mistakes!"). Also, it greatly hindered my creativity because once I had the lights set, I couldn't move them. I used Polaroids for years, not to check the exposure but to evaluate the composition and make sure all of the lights were firing. (I didn't use Polaroids as an exposure check because they reacted to light differently depending upon whether they were still cool from the refrigerator or were cooking at a hot location.) I certainly do not use the LCD screen on the back of my digital camera for an exposure check. (The density and color of the image changes as you tilt the camera in different ways—which one is accurate?)

No, the only way to accurately and consistently judge your exposure is with a quality light meter. There are two types of light meters, and they both do the same thing. An incident meter reads the light that falls on your subject and tells you the exposure for the middle of your latitude. A reflective meter reads the light that bounces off your subject and provides the value for the midtones. I personally prefer the handheld incident meter for the majority of my work. Place the meter at the critical point of the image—for example, at your model's cheek—and point the dome of the meter right at the camera, not the light! Use

Facing page—The discussion about exposure and metering is critical to understanding how to accurately expose an image. However, knowing these rules can also help you break them! Photography is an art form that lends itself to subjective creativity. This image of Kathryn is not properly exposed. In fact, it is overexposed and then manipulated further to enhance the overexposure. But for this image and the effect we were after, it is the correct exposure. The key is that the effect was created on purpose: we took the "rules" of how to properly expose a digital image and tweaked them to get this look. It must be noted that the image was not usable as shot. A Photoshop technique detailed on pages 34–35 was used to make the image work. **Right**—In contrast to the image of Kathryn, the photograph of Michelle was accidentally underexposed by about 1 stop. It took a couple of Curves adjustment layers and some specific color correction to get an acceptable image. The first Curves adjustment made the basic corrections and brought the flowers back to life. A second Curves adjustment brightened the whole image but blew out the highlights in the flowers. The flowers were brought back by "painting" them in using the adjustment layer mask. (To do this, select the mask in the Layers palette and use the Brush tool with the foreground color set to black to paint in the layer beneath the second Curves layer.) The Curves adjustments worked to bring the image back into an acceptable tonal range, but the underexposure created color shifts that needed correction. I used a Selective Color adjustment layer to fix the red shift. With the Red channel selected, I moved the Cyan slider to the right to add cyan to the whole image. I then made a second selective color adjustment layer and added a little yellow to the Red channel. Next, I used the mask and Brush tool to isolate the color correction to under Michelle's neck. Did this underexposed image work? Yes, but it would have been much easier to get it right in the camera.

this technique for any light that strikes the front of any part of your set. Meter all other lights (lights that add highlights to your subject's body or hair) by aiming the dome of the meter at the light source. Start by trying to keep all of your exposures within 1 stop of your main exposure. *Do* use your LCD to make sure that you are holding the highlights when your model is wearing white. Furthermore, many digital cameras are not true to their reported ISO (the digital equivalent to "film speed"). Some cameras are as much as a full stop under the rated ISO. It is extremely important to test your camera under controlled situations to determine your ISO! Understanding how to use your meter will help you previsualize the image and will help you place the shadows and highlights where you want them.

QUALITY OF LIGHT

Quality of light refers to the effect that your light source creates on your subject. It determines how soft or harsh the light looks in your image. Soft light will have a slow and gradual shift from highlights, to neutrals, to shadows. The shadows will be light and smooth. Harsh light will have a sharp transition from highlights, to neutrals, to shadows. The shadows will be deep and dark.

Another way to think about quality of light is to think about how much contrast the image has. Photographers use lighting ratios to describe the amount of contrast in an image. These numbers describe the amount of light illuminating

Quality of light refers to the effect that your light source creates on your subject.

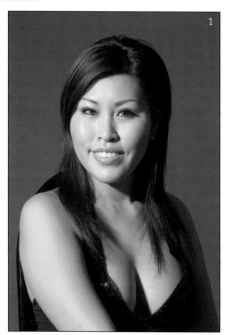 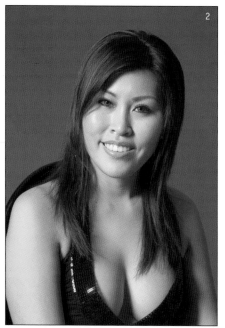 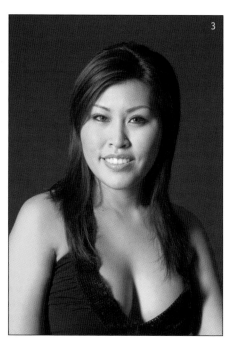

This image sequence shows the effect of the size of the light source on the quality of light.

Image 1—The spotlight is a harsh light source because of its relatively small size. The shadow off of Marissa's nose is deep and dark. The transition from highlight to shadow is quick and sharp. The specular highlight is focused and bright.

Image 2—The image created with the umbrella is still fairly harsh, but the larger light spreads the specular highlight a little and illuminates the shadow side more.

Image 3—The small StripDome creates a distinctly different look from the spotlight and umbrella, but it creates a harsher quality of light when compared to the other softboxes in this sequence. Notice the difference that the softbox makes in the color of the image. This has to do with the color temperature of the light source. We'll touch on color temperature issues later in this book.

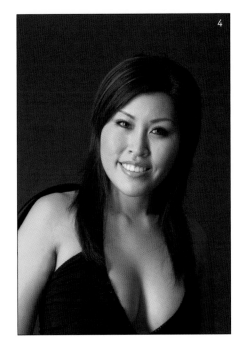

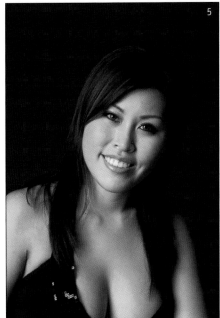

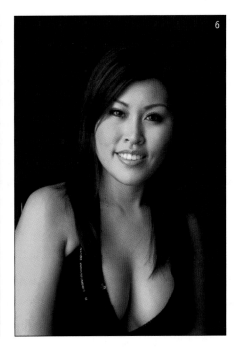

Image 4—The medium StripDome begins to show more of the softer light that is characteristic of soft-boxes. The wraparound effect is beginning to become apparent as the shadows on the left side of Marissa's face are less dense.

Image 5—The large LiteDome is one of my favorite modifiers. (*Note:* Different softbox manufacturers have different designations for their sizes. The softbox used here is about 30x40 inches.) It produces a beautifully soft light while maintaining a nice degree of contrast. The specular highlight is still apparent but is spread out. The shadow side of Marissa's face is still defined, but the shadows are soft and gradual.

Image 6—The extra-large LiteDome is a beautiful light source. (*Note:* Some companies consider the 40x60-inch box large rather than extra large.) The light is smooth and even across Marissa's face and into the shadows. The specular highlight blends into her skin. The extra-large softbox can be too soft for some applications but is perfect for other jobs. For example, the low-contrast light is great for photographing white garments against a white backdrop. We'll explore ways to take advantage of the soft nature of light from this sized softbox and still provide a "pop" to your subject's face.

A 1:1 ratio is very flat, and a 7:1 ratio is almost black and white.

the highlight side of the image versus the shadow side. A 3:1 lighting ratio will have less contrast and will therefore have a softer quality of light than a portrait with a 5:1 ratio. A 1:1 ratio is very flat, and a 7:1 ratio is almost black and white. Your choice of capture medium will also influence your lighting ratio. Black & white film can "hold" much more information than digital capture, so you can play with more dramatic ratios with the former medium.

Quality of light is influenced by the interplay of two factors: the size of the light source in relation to your subject and the distance from the light source to your subject. Keeping the distance from your subject equal, a larger light source will provide a softer quality of light than a small light source. Small light sources are focused and only illuminate a small section of your subject, whereas large light sources, when used properly, will light the area targeted and wrap around the subject to add light to the shadow side as well. Another telltale sign about the quality of a light source was introduced earlier: each light will leave a specular highlight—basically, this is a reflection of the light off of your subject. Small light sources leave highly focused and sharp specular highlights. Large light sources leave specular highlights too, but they are broader, more spread out, and softer. Consider the examples on the facing page and above.

If the size of the light source determines the quality of light, then why isn't the sun a good light source for most of the day? The size of the light source is only one factor in the equation; the distance of the light source from the subject also plays a role in how harsh or soft your light will appear. The sun is a huge light source. It is also very far away. The extreme distance that the light travels to reach the Earth (and your subject) turns the huge light into a pinpoint light source that creates deep, ugly shadows for much of the day. The series of images just displayed shows the dramatic difference between a spotlight and a 40x60-inch softbox. However, if we had the room (and power!), we could keep backing the big box up until it produced the same quality of light as the spotlight.

COLOR TEMPERATURE

Color temperature is important because selectively altering the color temperature of different light sources can be a creative field day! It is also very important to understand how color temperature works, because different types of lights will have different color temperatures. It was noted at the beginning of this book that some softboxes may be adapted for use with hot lights. Hot lights are simply lights that are on at all times—they may be floodlights, for example. Floodlights will have a different color temperature than either most strobes or high-noon sunlight (unless you get "blue" floodlights). Have you ever taken a photograph indoors with a roll of daylight-balanced film and the flash did not go off? The resulting image had an orange-amber cast to it because there was a mismatch between the color temperature of the film (or white balance) and the lights used to create the image. Most indoor incandescent lights are tungsten lights and have a lower color temperature than sunlight. Most floodlights are tungsten lights too. In contrast, most strobes are "daylight balanced," meaning they have a higher color temperature than tungsten lights. Daylight at high noon has a color temperature of about 5500 to 6000 degrees Kelvin. Tungsten lights are about 3200 degrees Kelvin. Blue floodlights are close to 5500 degrees Kelvin. Daylight can have different color temperatures too. Early-morning and late-afternoon sunlight has a lower color temperature than high noon. The color temperature of light in open shade, in the mountains, or under a cloud cover is higher than high-noon light.

Floodlights have a different color temperature than most strobes or high-noon sunlight.

Go back and review the images on pages 26 and 27, which showed the effects of different-sized light sources on the quality of light. The images taken with the softboxes were "softer" than the spotlight and umbrella, but they also have a different color. The spotlight was actually a strobe fitted with a 7-inch silver parabolic reflector. Lights that are reflected off of silver materials will have a higher color temperature. In contrast, light that is diffused by white materials (as is the case with softboxes) has a lower color temperature, resulting in a warmer image.

So, what do all of these numbers mean? Your capture medium (film or white balance on your digital camera) needs to be in sync with the color temperature of your light source or you will get a color cast to your images. The amber cast in the "flash didn't fire" image is there because the film/white balance was ex-

pecting a higher color temperature than the lights provided. Lights that produce a lower color temperature than your film/white balance anticipates will result in images with a warm amber color cast. Lights that produce a higher color temperature than your film/white balance expects will result in a cool blue color cast.

The color cast that results from a color temperature mismatch is not necessarily a bad thing. Sunset beach shots can be beautiful because of the amber cast. Selectively placing a light with a higher color temperature can result in dramatic fashion images or add distinction to an executive portrait. We will talk about how to manipulate color temperature for effect later. See pages 98–99.

THE ADDITIVE NATURE OF LIGHT

The additive nature of light is one of the more complicated aspects of light and lighting. It is mentioned here because we will be showing some fairly complex lighting schemes in this book. The exposure of each light has been meticulously determined to add a specific effect and to stay within the narrow exposure range of transparency film and digital capture. Simply stated, each light that is added to a scene will add to the overall exposure of the area that is lit by more than one light. You can figure out what each light will add to the scene because the amount of light added is directly proportionate to the other lights on the set. Light is measured in "stops," a term that describes the unit of light referred to by a given aperture. The aperture of your lens is actually a ratio of the diameter of your lens opening to the focal length of the lens. The term f-stop refers to the diameter of the lens opening, or aperture. Therefore, in this sense, "stops" is a relative term. Adjacent f-stops are exactly $1/2$ as large as the next larger aperture—or twice as large as the next smaller lens opening. For example, an f-stop with a value of f11 allows twice as much light into the camera as f16 and four times as much light as f22 because the lens opening is two times larger than f16 and four times larger than f22. Conversely, it is $1/2$ as large as f8 and $1/4$ the diameter of f5.6, so it lets in $1/2$ and $1/4$ as much light as the two larger openings respectively. This information helps you to understand and calculate how different lights interact and add to your exposure. For example, if you add a light that is 1 f-stop less than another light, then you will add $1/2$ of a stop of light to the exposure where the lights overlap. If you added a light that was 2 stops less than another light, then it would add $1/4$ of a stop to the exposure.

The additive nature of light also helps determine lighting ratios. When photographing people, you are concerned with controlling the range of detail from the highlight to shadow side of your subject's face. The highlights are determined by your main light. The main light determines the base exposure for your image and establishes the direction of your lighting scheme. The amount of light that illuminates the shadow side of your subject's face (the side opposite the main light that is not lit by your main light in a "traditional" portrait setup) depends upon whether you choose to add light to—or fill—the shadows. A very common lighting ratio is a 3:1 ratio. With a 3:1 ratio, there is three times more light on the highlight side than the shadow side. To use the f-stop examples listed in the previous paragraph, a fill light that is positioned to light both sides

. . . the amount of light added is directly proportionate to the other lights on the set.

of your subject's face equally and set at 1 stop less than the main light would add one unit of light to each side. The main light, in this case, would add two units of light to the highlight side (because it is twice as bright as the fill) and in theory (depending on your choice of main light), no unit of light to the shadows. Two units of light from the main light plus the one unit from the fill light on the highlight side, and the one unit from the fill in the shadows, results in a 3:1 ratio. You can play with other variations and combinations, but you won't have much luck beyond a 5:1 ratio given the exposure latitude of digital capture.

INTRODUCTION TO SOFTBOXES

Softboxes are a specific type of light modifier. They are designed to produce an even spread of light from all parts of the box. Your light fits into a housing that you use to attach the softbox. The housings will be different depending on your strobe or hot light. The number of connectors will also vary according to the shape of the softbox.

HOW THEY WORK

Softboxes work by spreading out the light from what would be a small specular light source. Softboxes are designed to go from narrow by the light to as broad as the outside dimensions of the softbox. The inside of softboxes are lined with highly reflective fabric—oftentimes bright silver. As the light travels through the expanding corridor, it bounces around the inside of the box, reflecting off of the fabric in all directions. It is no longer a spot source of light by the time it reaches the outside diffusion material. Rather, it becomes a wall of light that is equal at all points. It is this wall of light that is further diffused as it passes through the outside diffusion material. Note that you can use different-colored panels to line the inside of your softbox to change the color of the light illuminating your subject.

There are usually two sets of diffusion material that the light waves pass through before illuminating your subject. The first is known as a bevel. This is a thin piece of translucent white fabric that attaches to the inside of the softbox. This material is usually fairly close to the light and provides the initial diffusion. The now diffused light continues to travel through the softbox until it hits the outer translucent white material. The outside dimensions of the box determine the size of your light source, creating a larger (and hence softer) light source than what you attached to the softbox. Furthermore, the light leaving the softbox is diffused twice, and this softens the light even more.

Softboxes work by spreading out the light from what would be a small specular light source.

WHY USE THEM?

Light, in most cases, needs to be diffused before it will give you a pleasing photograph. Spotlights can produce very dramatic fashion images—partly due to the harsh quality of light, but also to the repetitive shadow patterns that can be created. However, diffused light has many more applications.

HOW TO USE THEM

Every light source has an "ideal" distance that allows you to maximize its design. In the case of a rectangular softbox, you use the Pythagorean theorem to determine the theoretical distance that will optimize the contrast of the box while maintaining its quality of light. You would have two right triangles if a rectangular softbox were dissected along its diagonal.

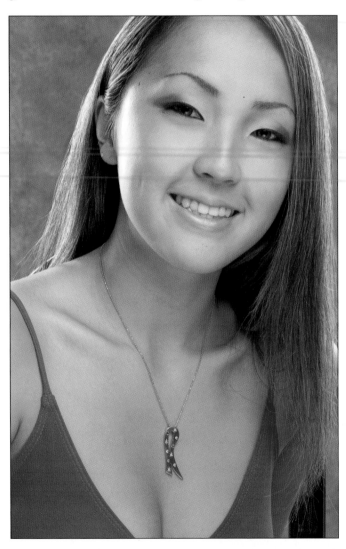 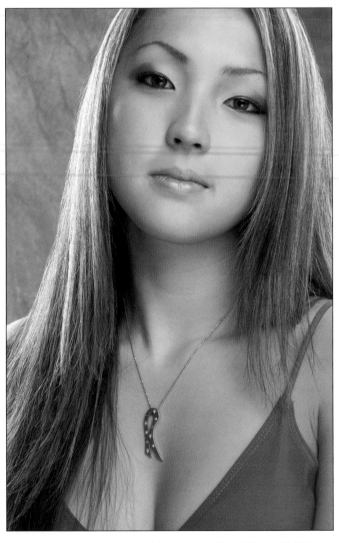

Left—The double diffusion design of the softbox yields a beautifully soft light that is perfect for beauty headshots. The quality of light will differ depending upon the size of the softbox, but it will still be softer than the spotlight. In this case, a 30x40-inch softbox was fitted with a Circlemask to create this beauty image of Midori Every. The Circlemask creates round catchlights that look natural. The main light was metered at f11³/₁₀ with a silver board in place to bounce light back under Midori's chin. Two medium StripDomes were used as hair lights. The image was exposed at f11—¹/₃ of a stop overexposed. I will show you a step-by-step breakdown of how to create a beauty headshot later in this book. **Right**—The inside bevel is just one of the things you can modify to change the effect created by the softbox. Here, we removed the inside bevel and created a beauty image with a little more "pop" than we had with the bevel attached. The new exposure was f11⁷/₁₀, so the inside bevel "eats" almost ¹/₂ a stop of light! We turned down the strobe to f11³/₁₀ to make the exposure the same as the shot with the bevel. The light is still soft enough for general use, and the technique may help if you do not have powerful strobes and you need all the output you can get.

Diagram and right image—We created a very dramatic glamour headshot of Tishanna by keeping the inside bevel but removing the outside translucent fabric. In this case, we created a fairly large spotlight that was softened a little by the inside bevel. The exposure from the softbox was f11. The hair light was a small StripDome set to $f11^2/_{10}$. There was also a spotlight with a 10-degree grid that illuminated Tishanna's hip when we backed up and shot full length and $^3/_4$ poses. The spotlight was also set for f11. You need to be extremely careful when lights overlap on your subject. In this case, we had to be even more careful because Tishanna put baby oil all over her body and hair to add a shimmer to the reflections from the light and accentuate the "glamour" feel of the image. The shine made it more difficult to control the highlights. The combination of the softbox and spotlight on her hip was $f11^4/_{10}$—well within my desired range of 1 stop from the working aperture.

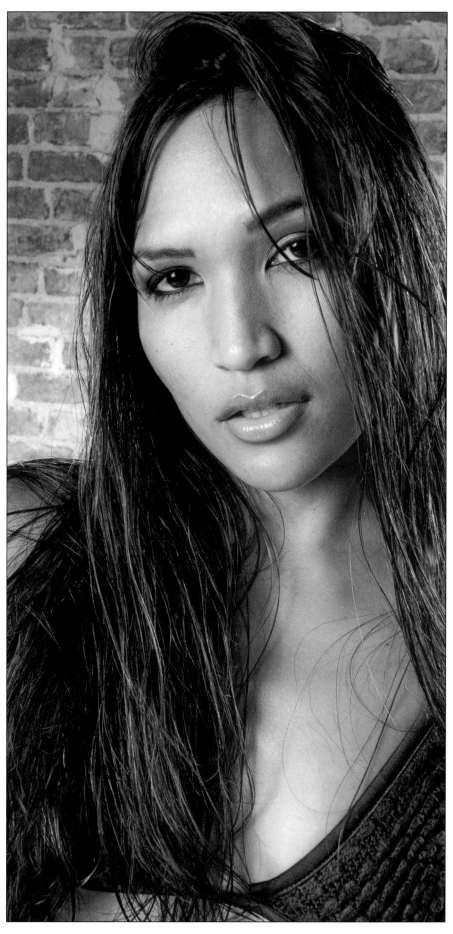

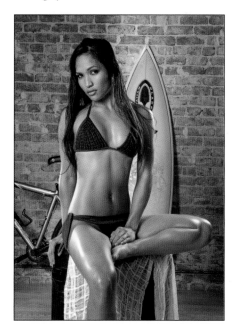

This $^3/_4$ pose shows the effect of the lighting technique just described. In this case, the hair light was set at $f11^2/_{10}$. Both images were exposed at f11.

PHOTOSHOP TIP: USING CURVES AND LAYER MASKS TO EMPHASIZE AN EFFECT

Earlier in this book, we showed an image that was overexposed and manipulated in Photoshop. One of the things that I love about photography and Photoshop is that there is no end to the learning. The techniques get more detailed as you go, but will become easier with practice. The overexposed image of Kathryn on page 24 was created in a way similar to the following techniques used to create a dramatic beauty shot of Midori Every.

1. We started with a beauty shot without the inside bevel (see page 32) and simply set the aperture to f8 rather than f11.

Image 1—Simply overexposing an image by 1 stop will not necessarily give you the desired look when you are creating an image with blown-out highlights. **Image 2**—The Curves adjustment was created by pulling up from the center spot of the curve.

Image 3—I used the Brush tool set to black to paint back in some of the darker details from the underlying layer. **Image 4**—My attempts to darken Midori's hair and the backdrop worked against me here . . . but it really is only a temporary setback in the overall process.

This change added a full stop of light to the image. I hit Ctrl/Cmd + J to create a duplicate layer and used the Healing Brush and Clone tools in Photoshop to take out any flyaway hairs and do some minor retouching (Midori is a beautiful young lady with nearly flawless skin!).

2. Overexposing the image by a stop results in a photograph with blotchy highlights. This looks like a mistake, but it provides a perfect framework for what we will do next! Hit Ctrl/Cmd + J again to create a new duplicate layer.

3. We are going to apply a Curves adjustment to the new layer. Normally I would use an adjustment layer for this manipulation, but I know the effect I am looking for, so I hit Ctrl/Cmd + M to open the Curves dialog box. (Adjustment layers are the way to go in most cases because they provide the flexibility to change the manipulation later, and it doesn't actually change the pixels in your original layer. In this case, we are performing the Curves adjustment on a duplicate layer, so we still have the original layer in its unmodified state.)

4. The change was created by simply choosing the center spot of the curve's diagonal and pulling straight up until I got the look I wanted. (Make sure that the curves box is set to light as you pull up—if it is set to print mode, then pulling up will make the image darker. This control is the set of arrows along the bottom of the Curves grid.) The highlights now blend beautifully. However, we have lost too much detail in Midori's hair, eyebrows, and lips. I went to the Layer drop-down menu and chose Add Layer Mask>Reveal All.

5. I chose the Brush tool and set the foreground color in the toolbox to black. Black will paint the underlying layer back in, and white will paint the current layer in. With the Brush tool active, you can utilize the Opacity slider in the Options bar to control how much of the underlying layer shows through.

6. I wanted to bring back some of the density in Midori's eyebrows, eyes, lips, and hair. Each section required a different opacity setting, and I just played with the values until I got what I wanted. If you choose an opacity that lets too much of the underlying layer back in, then just set the foreground color to white, change the opacity of the Brush tool, and paint the current layer back in!

7. The background and Midori's hair were still a little too light for what I wanted, so I made a duplicate layer of the current masked layer and changed the blending mode (upper-left corner of the Layers palette) to Multiply.

8. The Multiply blending mode takes all the pixels from the underlying layer that are less than 50% grayscale and doubles them. The result for this image seems to defeat the purpose of this

whole exercise. The background and hair are darker, but so is Midori's face!

9. The solution was simple. I set the foreground color to black, selected the Brush tool, and painted her overexposed skin tones back in! I saved a version with all the layers intact then flattened the image and finally retouched some minor flyaway hairs that I had missed the first time through and was finished . . . or so I thought. I looked at the final image and saw some parts that I wasn't quite happy with: the skin tones on her arm at the right side of the image were too dark and her lips were still too light. I opened the version with all the layers intact and selected the first layer mask and painted her lips back in at 30% opacity. Then I selected the second layer mask and erased the multiplied layer at her arm. Once again I saved this layered version, flattened it, redid the minor retouches, and was finished.

Image 5—The effect can be accomplished with an accurately exposed image too. The benefit of using a properly exposed image and duplicate layers is the original file contains all of the information needed to use the image for other purposes. Overexposing your image for this effect is great—if you want only the overexposed image. Digital capture now gives you the choice.

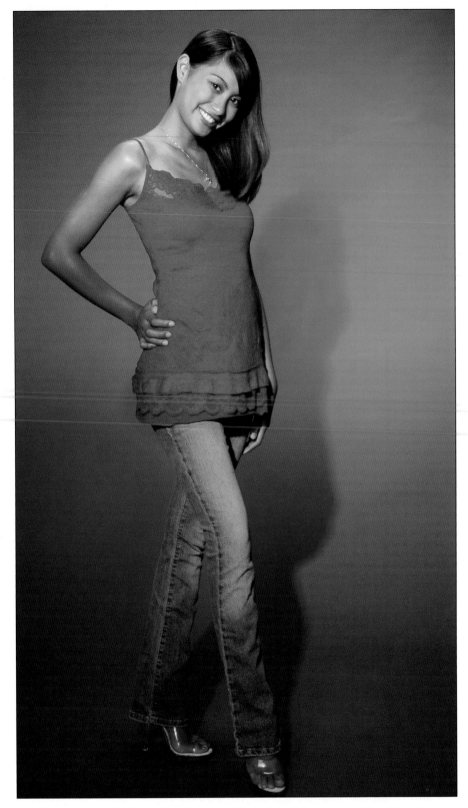

The extremely small lights create a harsh lighting effect that can add some snap to an image. Here, we used a couple of spotlights with honeycomb grids to add a stylish look to blue jeans. Two spots were positioned directly behind the camera and aimed at Ruthchelle Melchor's face and torso. The falloff from the lights places her legs and feet in relative shadow, drawing your eye to her face. The spotlights also create a strong shadow behind her, adding a new graphic dimension to the image. The gray seamless backdrop was also lit with a spotlight without a grid, but covered with a green gel. Honeycomb grids come in varying degrees and narrow the beam of light even further—creating a smaller and even harsher light source!

The theoretical ideal distance would be the hypotenuse of the right triangle. The Pythagorean theorem tells us that the hypotenuse (C) is obtainable via the following equation: A^2 plus B^2 equals C^2. Let's assume that A=40 inches and B=30 inches for a fairly standard 30x40-inch softbox. A^2=1600 and B^2=900, so C^2=2500. The hypotenuse, C, is determined by taking the square root of 2500, which is 50 inches. The theoretical ideal placement for a 30x40-inch softbox is

50 inches from the subject! However, as we saw in the beginning of this book, there is a less scientific (and easier) way to judge the proper distance from the light to your subject: watch the light as you pull the softbox closer to your subject, and stop when his or her face "pops."

SIZE MATTERS

We saw earlier that the size of your light source will have an impact on how your photograph looks. Understanding quality of light issues is the first step in using softboxes creatively. The image below, and those that follow, were created using different sized softboxes—some in isolation and others in conjunction with other light sources.

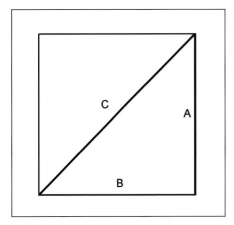

The Pythagorean theorem can be used to determine the theoretical distance that will optimize the contrast of the box while maintaining its quality of light.

A small StripDome was the main light for this elegant and fashionable portrait of Aiko. The small light source focuses a direct and harsh quality of light onto her face and shoulders, but the diffusion material keeps the light from being too harsh. The falloff of light is also dramatic. Aiko's hair and makeup were done by Mayumi Kondo.

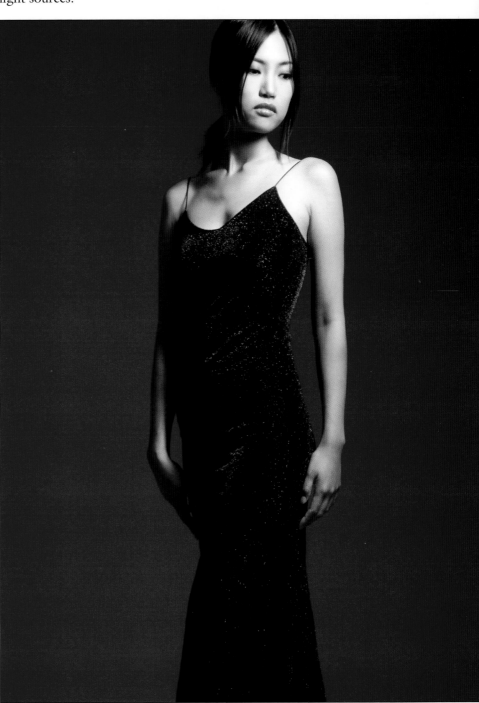

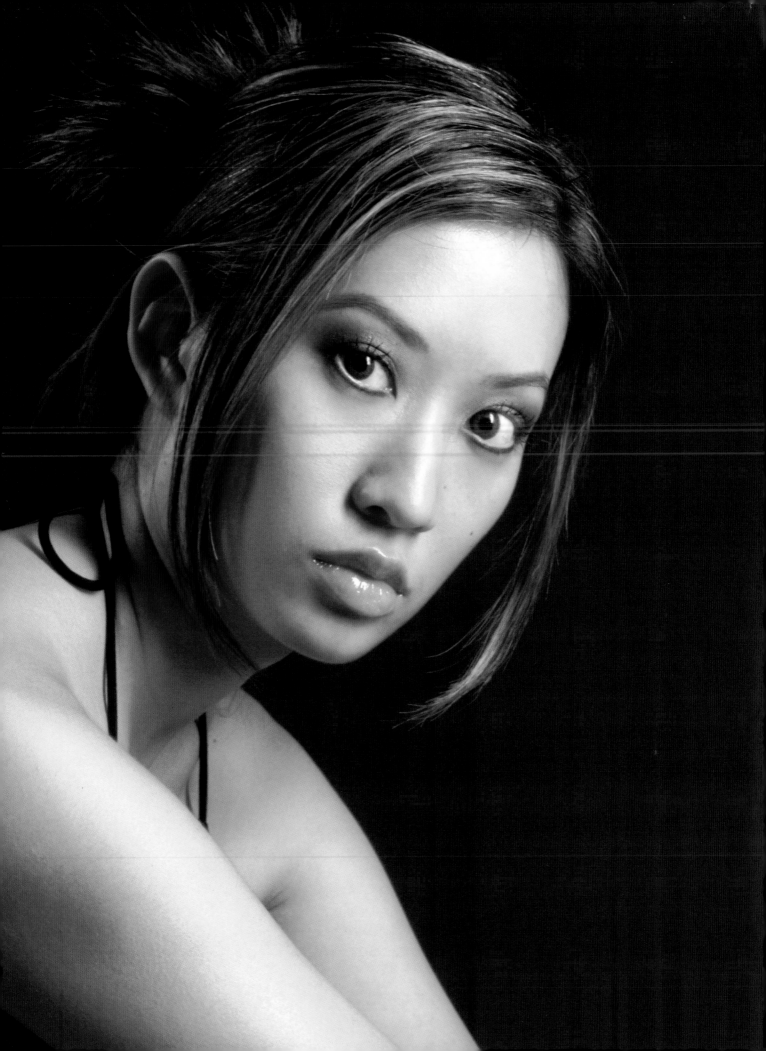

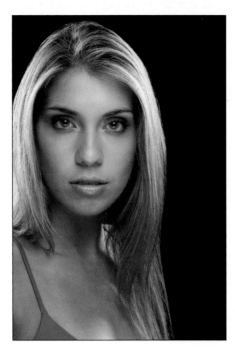

Facing page image and above diagram—Brooke Tanaka was lit with two medium StripDomes—one was positioned on either side of her. The main light produces a nice effect because it is positioned along the axis of her nose, but placed a little high to create some shadows. The light from the medium StripDome is beautiful but is still a fairly specular light source. Notice the hot spot on Brooke's forehead and along her nose. The light still produces a nice shadow on her cheek even though it is right in front of her.

Left image and diagram—The large (30x40-inch) LiteDome produces perfect light for my version of beauty lighting. The light is positioned high and in front of Callie. Light is also bounced up from a silver card (a California SunBounce in this case) to fill any shadows created by the LiteDome. Ashley designed the hair and makeup for this image. **Right image and diagram**—The extra-large (40x60-inch) LiteDome is my first choice for photographing delicate white fabrics such as the brassiere worn by Teresa Bringas. The light is broad and soft with little contrast, so there is little worry about losing detail in the whites. A little "pop" was added to Teresa's face by using a spotlight for a fill light.

HALOS

A Halo is simply an umbrella that works like a softbox—or it is a softbox designed like an umbrella. In this case, the strobe fits into the "umbrella" and a silver-lined back fits around the strobe and seals with a Velcro strip. Halos can be set up so the strobe shoots through the translucent fabric or is bounced into the silver backing and then through the front fabric. The effects of the two uses are subtly different. The two images of Midori Every were created to demonstrate the differences in shooting through a Halo versus bouncing the light against the silver lining first.

The image with the bounced light shows a softer quality of light. However, as we will see later, there are certain steps needed when shooting against a white

backdrop. I blew the shot on two counts: I lit only one side of the white back-drop, so I had nasty falloff on the other side. I also neglected to take the third critical meter reading (see pages 60–61)—the reading on the backdrop was not as high as usual, so I "assumed" everything would be okay . . . and I was okay—after some fancy Photoshop work! Lesson learned: "shortcuts" have no place in digital photography. Do the work before pushing the shutter, and life will be a lot nicer in postproduction!

Halos, like other softboxes, come in different sizes, and the effect obtained is related to the size of the gear. A large Halo was placed in the doorway from the kitchen to this living room to create a "window light" effect. Bella was turned into the light to avoid a "split light" effect, where only half of the face is lit.

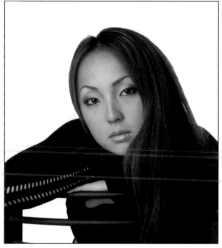

I had to rely on a mask and Curves adjustment layers to get the white backdrop I wanted, and a Multiplied layer and more layer masks to "fix" a slight flare that came from the light bouncing back from the backdrop. Fortunately, the flare was not too bad, and I was able to turn it into a usable image. The problems stemmed from not following my usual pre-shoot routine. It won't happen again!

The Halo was placed to Bella's right at a 90-degree angle to the camera. This position would usually create a side, or "split," lighting effect. We turned Bella into the light to allow the shadow side of her face to receive some illumination. A spotlight was aimed at the ceiling over Bella's head to bounce some light into the shadows behind her.

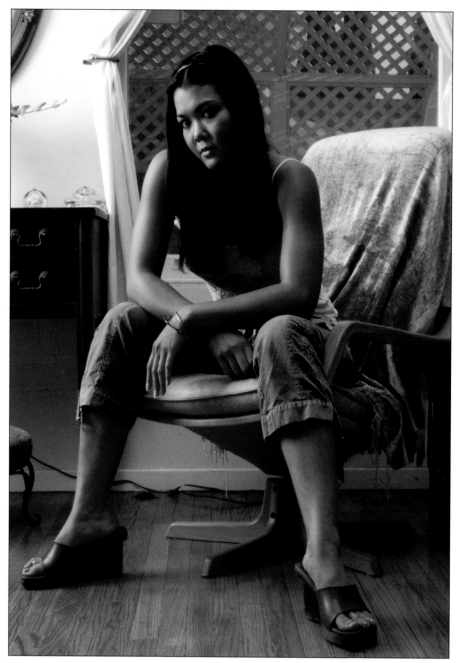

Halos are an effective solution to bringing a softbox on location—it folds up like an umbrella, so it is easily transported. There are many times that you will need to modify outdoor light, and one way is to add a strobe. The benefits of using a softbox indoors are also apparent outdoors: the light is broader and softer than direct sunlight or a straight strobe. Once again, soft light works in many more circumstances than harsh light.

STRIPDOMES

StripDomes are prominently featured throughout this book. They are thinner versions of standard rectangular softboxes and have many uses. StripDomes make beautiful hair and rim lights but also work as main lights in some applications. StripDomes come in various sizes, and the contrast ratio increases as the size decreases.

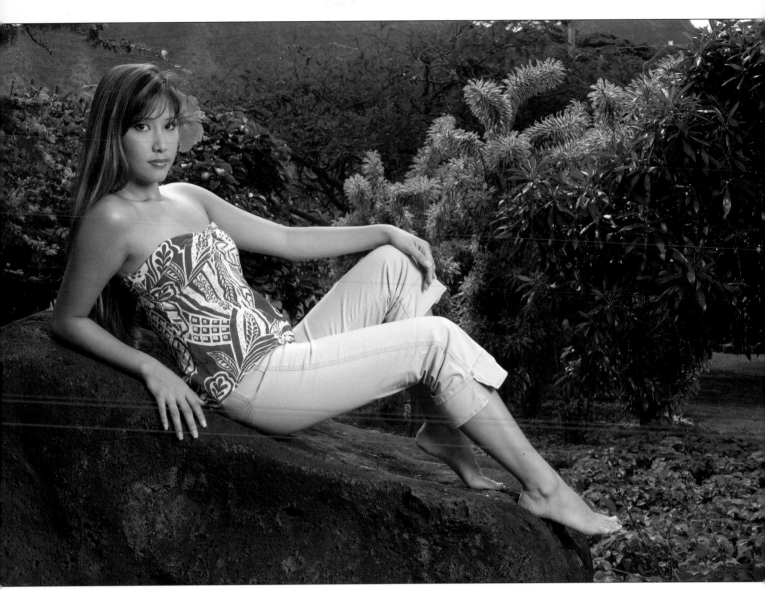

Ashley was photographed in a small park in Oahu, Hawaii. It was a day filled with hazy sunshine. The sun was too high in the sky to be used as main light because the shadows would have been too deep and dark. Ashley was positioned with the sun behind her, so her hair and the foliage was beautifully lit by the sun. The main light for this image was a monohead strobe light tucked into a Halo. A bit of technical information is needed to understand how and why this image worked. The sun was high in the sky but was still behind Ashley, so light was coming into the camera lens from behind her. At best, we would have overexposed the background if we had taken a meter reading from her cheek to the camera; at worst, we would have had flare from the backlight degrade the image. We used the strobe to balance the main light with the background. First, we took a meter reading behind her toward the sun to gauge the light hitting her from behind. For argument's sake, let's say that the exposure read f8^6/$_{10}$ at 1/$_{250}$ of a second. Next, we set up the Halo–strobe and metered the combination of natural light with the strobe at her face. Let's say the combined reading was f8^9/$_{10}$ at 1/$_{250}$ of a second. That combination would work in theory because the light hitting her from behind was less than the exposure we set on the camera. However, I was uncomfortable with this for a couple of reasons. The exposure range was a little too close to my comfort zone and it was too bright for me to use the LCD screen to check for flare if the sun burned through the haze a little more. I was also concerned that the highlights on her skin that were created by the sun would lose detail. The solution to both concerns was to set the meter (and camera) to 1/$_{500}$ of a second and re-meter the combination of natural light and light from the strobe. Changing the shutter speed dropped the ambient light by a full stop but didn't change the output of the strobe. The strobe became more of a main light because its effect was now more apparent, but the overall amount of light illuminating Ashley didn't change as dramatically. However, the light from the strobe drops off dramatically as it passes her, so it has no effect on the background. The light behind her was now 1 stop less than the main light combination, so flare and blown-out highlights were no longer a concern. The hazy sunshine behind Ashley was still fairly harsh, and the difference between the backlight and main light wasn't that great, so there were plenty of specular highlights to add visual interest to the scene.

Right image and diagram—Tara Rice was lit with a single medium StripDome positioned at camera right as a main light and a second Strip-Dome off to the left as a hair/rim light. The image was created as part of a commercial shoot, so I don't recall whether the hair light was a small or medium StripDome. The white backdrop was lit with two spotlights. **Image and diagram below**—Medium StripDomes were used as rim and hair lights in Michele Pestel's variation on the same theme. The main light was a 30x40-inch softbox positioned directly behind the camera with two spotlights on either side of the box. The spotlights were fit with 30-degree grids and were each set at $^8/_{10}$ of a stop less than the main light. The image had to be slightly underexposed because the spotlights were too harsh for Michele's sparkly tank top. The image was not dramatically underexposed and was easily restored with a Curves adjustment layer in Photoshop.

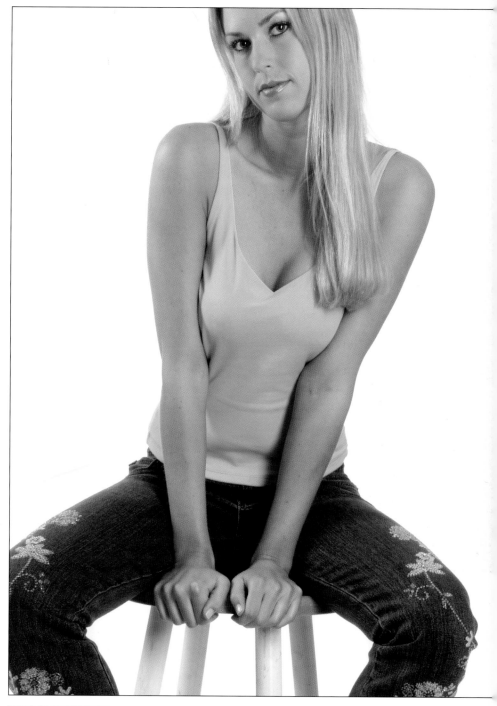

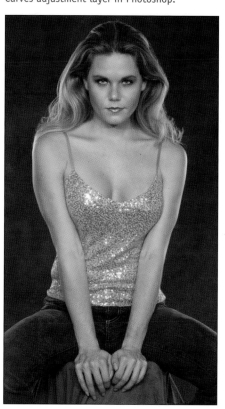

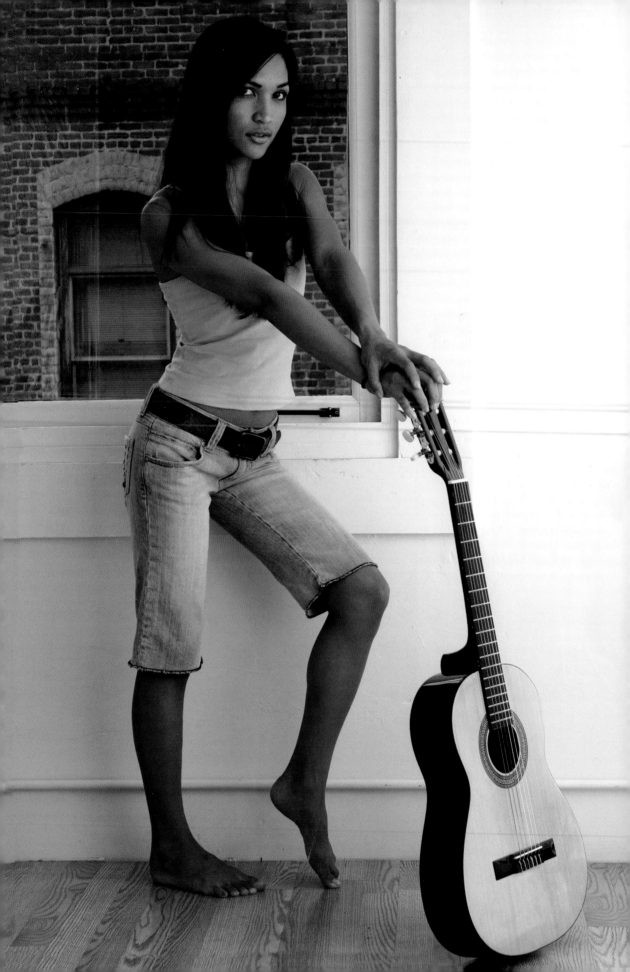

Facing page image and above diagram—Scrims can be used to create an effect much like a softbox. Here, a strobe illuminating a large scrim is used as the only light source for a naturalistic portrait of Tishanna Yabes. A large gold reflector was used as a fill source.

SCRIMS

Scrims are simply frames with a translucent fabric stretched over them. Scrims are often used outdoors to soften the harsh light of the midday sun. However, they can also be used in the studio to create an effect much like a softbox. Like many light modifiers, scrims come in different sizes. We chose a fairly large scrim to create the image of Tishanna on the facing page. She wanted a very natural feel for the portrait of her with her guitar. We chose a very casual outfit and had her go barefoot to go with the laid back attitude of the shot. She was positioned by a window, so we wanted to simulate window light to suit the mood. We set up a 77x77-inch LitePanel scrim and backed a strobe up far enough for it to illuminate the whole scrim, resulting in a beautifully soft yet directional light source. A 77x77-inch gold reflector was positioned on the opposite side of Tishanna for a fill.

CIRCLEMASKS

Circlemasks are covers that fit onto the outside of certain rectangular softboxes and change the illumination from a rectangular source of light to a round one. The main effect of using a Circlemask is to create round catchlights in your subject's eyes. (Catchlights are the reflections of the light source that we see in our subject's eyes.) Catchlights are important because they add a sparkle to your image. Round catchlights look more natural because they mimic the catchlight we get from the sun.

Circlemasks provide an added benefit when shooting in tight spaces. I use them for my beauty lighting. My camera is set up directly below the softbox in order to achieve the look I am after. I often cannot have the softbox in the vertical position due to space limitations. Turning the softbox to a horizontal position helps with the space issue but creates a lighting problem: I do not want a wide light source for these images—I rarely if ever want to use the softbox in a horizontal position when shooting portraits or fashion because it spreads the light in what I think is an undesirable way. (Wide lights can make your subject look heavier than they are.) The Circlemask creates a round light source no matter what the orientation of the softbox. There are several examples of beauty headshots in this book. Take a close look at the catchlights in the eyes—if they are round, then the Circlemask was used to create them. (See the photo example on page 46.)

LOUVERS

Louvers are a set of thin black strips that fit over certain softboxes and narrow the spread of light that leaves the softbox. The louvers act as flags that block light from spilling beyond where you want to direct it. They are particularly useful in small studios where you are shooting against a dark backdrop. Softboxes can throw a lot of light behind your subject and partially illuminate your backdrop—even when it is feathered properly. The amount of light hitting your backdrop will vary depending on the size of your studio and how far you position your subject from the backdrop. Louvers help control the spill over of light, and you will be better able to keep your backdrop as dark as you want it. See page 47.

Facing page—Notice the catchlights in this beauty photograph of Marie Wourms. The catchlights are round rather than the rectangular shape that you would get from a regular softbox. The round reflections are created by placing a Circlemask over the 30x40-inch LiteDome softbox. Teresa Bringas styled Marie's hair and makeup.

Louvers also have an impact on how your subject is illuminated. Naomye (page 48) was photographed with a 30x40-inch softbox and a silver reflector. A spotlight was added as a hair light. The only difference between the two images is the addition of louvers to the second image. The light on Naomye's face seems much more directional. Just as the louvers cut the spill from illuminating the backdrop in the series of Riesey, there is less spill into the shadows on Naomye's face. The effect is apparent here, even though a reflector was used to create each image.

STRIPMASKS

StripMasks fit over certain softboxes and turn them into StripDomes. They can be very effective when you want a narrow light source but don't have Strip-

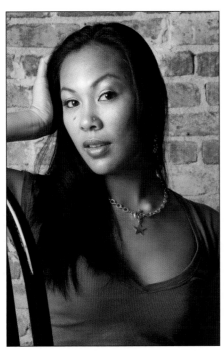

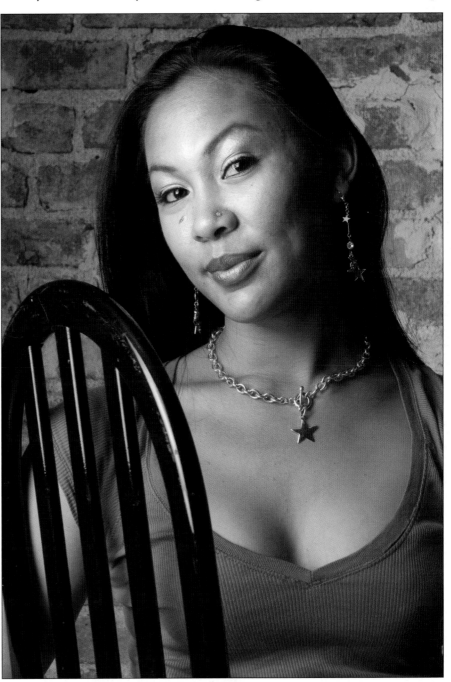

Above—Riesey was positioned about 5 feet from a brick wall backdrop. A softbox was positioned at camera left, and the softbox was feathered to spread light around her face. Even though the light was feathered away from the backdrop, there is still a considerable amount of spill that brightens the bricks. **Right**—Louvers shield the light from spilling past Riesey by acting as mini flags that block the light from going anywhere beyond where you aim the softbox. The louvers are black, so they physically block and "subtract" excess light from the subject or scene. ("Subtractive" lighting is where you use black materials to "eat" light and create shadows instead of highlights.) Be sure to re-meter if you add louvers to your softbox. The louvers "ate" almost ½ of a stop of light in my test. Some softbox manufacturers produce grids rather than louvers. Grids are like louvers but look like a series of squares rather than long rectangles. Grids may offer even more control than louvers but also probably "eat" more light.

Domes. The creative uses and benefits of narrow lights are discussed throughout this book.

PARABOLIC REFLECTORS

Strobes generally consist of a bare flash tube that sends light in a 360-degree circle. Parabolic reflectors are silver semicircular housings that usually fit over the front of the strobe to help focus the direction of light emitted. Parabolic reflectors turn a barebulb flash into a highly efficient spotlight, but generally don't have much use with softboxes. However, we discovered a possible use for parabolic reflectors in softboxes. See the left image on the facing page.

Combining Parabolic Reflectors with Louvers. Playing with different combinations of your tools is part of the fun of learning about your lights. We've seen how louvers change the look of the image. Parabolic reflectors can also be used

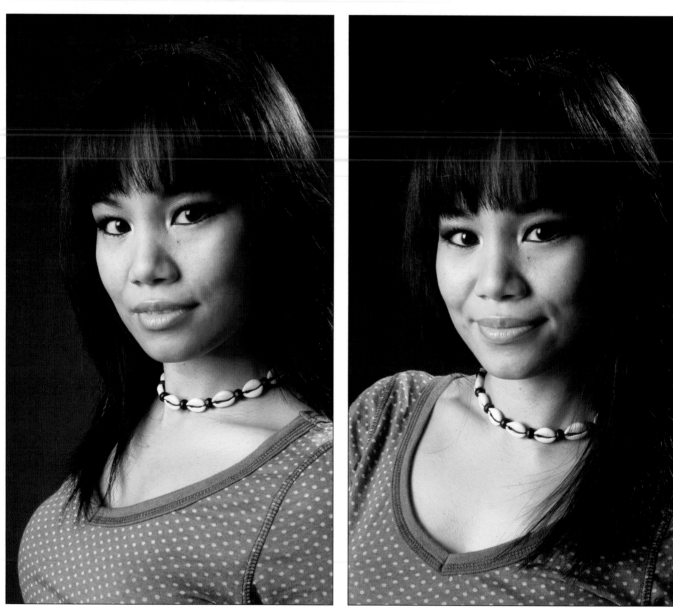

Louvers cut down the amount of light spilling onto your backdrop from your main light. They also shield light from illuminating the shadow side of your subject's face, creating a more directional look to the light and a higher lighting ratio—even with the use of a reflector. The effect is even more apparent when reflectors are not used, as in the series of images of Riesey on page 47. Naomye is featured in the images above.

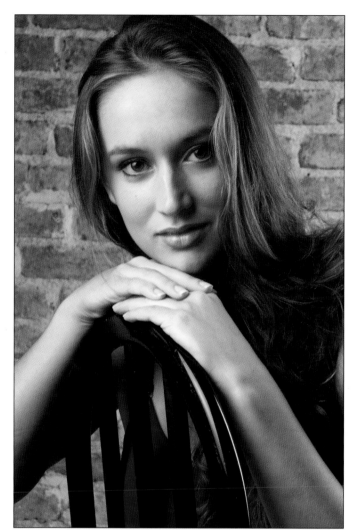

Left—The light from the softbox was narrowed somewhat by attaching a 7-inch parabolic reflector to the strobe inside the softbox (one of my assistants came up with this technique to keep light from escaping from old StripDomes that don't quite fit their frames anymore, but this was the first time we used it in the softbox). You can still see a good deal of detail in the bricks even with the parabolic cone attached. Model: Marie Wourms. Hair and makeup by Teresa Bringas. **Right**—The softbox becomes a diffuser for a much harsher light source created by the narrower beam created by the parabolic reflector and the louvers. I think this effect can be used in dramatic fashion, but I personally think that it is a little too harsh for this soft portrait of Marie Wourms.

to narrow the beam of light illuminating the interior of your softbox. The two effects are combined in the above-right image.

GRIDS

Grids are honeycomb-shaped accessories that fit over your strobe housing (or parabolic reflector) and narrow the beam of light to a distinctly focused area. They are very useful in lighting a specific and particular part of your set. Gridspots (a strobe fitted with a grid) are especially useful when used as hair lights but can be quite interesting as main or co-main lights. I often use gridspots as fill lights in conjunction with larger softboxes. You'll see many images produced with this very useful tool throughout this book.

REFLECTORS

Reflectors are tools made of light or shiny material that are used to catch light from one source and reflect, or "bounce," the light somewhere else in the set. Reflectors are commonly used as fill sources, catching the light from the main light that spills past your subject and bouncing it back into the shadows created by the main light. Reflectors are great when creating portraits and are an integral part of my beauty headshot setup. The proper placement of your reflector and ways to control the amount of fill created are discussed in the next chapter.

USING SOFTBOXES AND ACCESSORIES

PORTRAITS

Softboxes are beautiful light sources for formal portraits. The 30x40-inch softbox is one of my favorites for the reasons detailed in chapter 2: used properly, this softbox provides a soft yet directional light with a nice falloff that creates a pleasing lighting ratio—even without a fill light source. Feathering the softbox and positioning your subject in relation to the direction of the light are keys to effectively using this single main light.

Portraits are often lit with one source. However, that does not mean that you cannot play around with your lights when creating portraiture. The image of Stephanie Usita (facing page) was created using four lights in a fairly complex lighting scheme. The main light was a Halo positioned camera right. The fill was a 30x40-inch softbox placed directly behind the camera. A medium StripDome lit the right side of Stephanie's body, and a spotlight with a grid was used to light her hair.

Softboxes are also excellent tools for commercial headshots. The commercial headshot is an actor or actress's calling card. It has to stand out among the hundreds of headshots that cross a casting director's desk. The lighting needs to be fresh, clean, and not distract the viewer from the actor's face. One approach that works very effectively is the following four-light setup.

We start with the 30x40-inch softbox at a 45-degree angle at camera left. (There is no "rule" for placing the main

This engaging portrait of a newly crowned beauty queen was created with one main light: the 30x40-inch softbox. The softbox was placed with the inside edge lined up with Keaolani Mento's face. This is a technique known as "feathering the light" and makes the most of your light source. Keao is positioned with her face turned into the light, illuminating the mask of her face and allowing some of the light to "spill" into the shadows on the opposite side of her face. The ratio from highlight to shadow is pleasing. Keaolani's face is turned into the light, so the distance from her nose to her ear on the highlight side appears narrower than the distance from her nose to her ear on the shadow side of her face. This is an example of "short lighting." While the technique was not needed with Keao, short lighting can be used to "thin" a broad face because a larger part of your subject's face is in shadow. A small StripDome was used for a hair light. The white sash created a problem even though it was opposite and lower than the main light. The white satin was highly reflective and detail was lost—even though the image was perfectly exposed. A couple of Curves adjustment layers and layer masks made the image work.

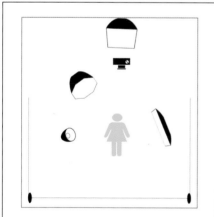

Portraits do not need to be created with only one main light. Have some fun with your tools!

light camera right or left, but I find that it is less distracting to keep the light going from left to right because we are used to seeing things in that direction.) The exposure for the main light in this case is set for f8⅝₁₀, and the camera is set at f11. The result is a dark and underexposed image (see page 52).

A fill light is used to add light to the shadow side of your set without changing the impact or direction of the main light. You could use a reflector to catch light from the main light that spills past your subject and bounce it back into the shadows. You could also use a second strobe positioned to add the same amount to both sides of your subject's face. My choice for images of this type is a second strobe because I can control exactly how much light I add to each side of my subject's face. My usual choice for a commercial headshot is a 3:1 ratio (see pages 26–29 for a brief discussion on lighting ratios). In this case, the fill light was set for f5.6⅝₁₀. This setting will add ½ of a stop of light for a combined exposure of f11.

The exposure on Mapuana's face is now set, and there is a nice 3:1 ratio from highlight to shadow. The image could work as a dramatic portrait, but there is still more work to be done before it works as a commercial headshot. The next step is to add a hair light.

Left—The four-light commercial setup series started with the softbox placed camera left at a 45-degree angle. The light was set for f8⁵/₁₀, which resulted in an underexposed image at f11. We'll fixed the exposure problem by adding a fill light. **Center**—The addition of a second strobe set for 1 stop less than the main light added $^1/_2$ of a stop of light to the equation. The strobe was fitted with a 20-degree grid to narrow the beam of light to illuminate Mapuana's face and fill the shadows opposite the main light. **Right**—The addition of a hair light helps to lift and separate Mapuana from the backdrop. In this case, a spotlight with a 20-degree grid was used. The exposure of the hair light was metered with the dome of the light meter pointed at the light and was set at f11—just like the main/fill combination.

The four-light commercial headshot is completed by adding a backlight. You decide how bright or dark you want your backdrop to be in relation to your foreground. In this example, we set the backlight to be equal to the main/fill combination.

Some commercial headshots need to be in black & white, but many digital cameras do not have a black & white capture feature. There are many ways to convert an image to black & white in Photoshop. The simplest way is to click on the image drop-down menu and choose Mode>Grayscale. This technique works, but it often results in a flat image that needs to be finessed with a Curves adjustment. A better but more complicated approach would be to use a Channel Mixer adjustment layer, as follows.

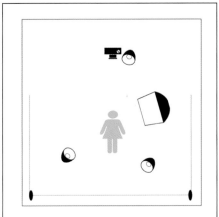

Left—The addition of a backlight completes this setup. The light illuminating the backdrop is lighting the front of the backdrop, so it is metered with the dome of the meter pointed at the camera lens. The light for this image read f11 at the backdrop. **Center**—A Channel Mixer adjustment layer was used to convert this image of Mapuana into a black & white headshot for her to send to commercial talent agencies. There are several key reasons for choosing this approach over converting from RGB to grayscale mode. You have much greater control over the final image and maintain the color information of the original layer for future use if need be. The monochrome adjustment is on its own layer and can be modified with ease. You can also lower the opacity of this layer to allow some of the color layer to show through. **Right**—Here we simply took the opacity of the Channel Mixer layer down to 61% to create a hand-tinted feel to the image. Mapuana's beautiful eyes were selected from the original layer and made into their own layer (Ctrl/Cmd + J). The Eyes layer was then positioned above the Channel Mixer layer.

1. Go to the Layers palette and click on the Adjustment Layer icon. Choose Channel Mixer.
2. Click Monochrome in the bottom-left corner of the Channel Mixer dialog box.
3. Adjust the Red, Green, and Blue channel sliders to create the black & white image that you desire. *Note:* The combined values of the three channels are supposed to come close to 100 but need not be exact.

Thanks to Martin Evening for describing this technique in *Photoshop 6.0 for Photographers* (Focal Press, 2001).

Reflectors can be used in place of an additional strobe to add light to the shadows in your scene. Note that reflectors do not technically "add" light to the scene. Rather, they "catch" light from the main light that passes your subject and bounce it back into the shadows. The angle at which you place the reflector will have a great impact on how it works. When creating your setup, place the reflector on the opposite side of your set from the main light, but in front of your subject. Ensure that the reflector is placed at an angle perpendicular to the main light.

Reflectors are less exact tools than strobes for filling shadows. However, you do have some control over how your image looks when using reflectors. The

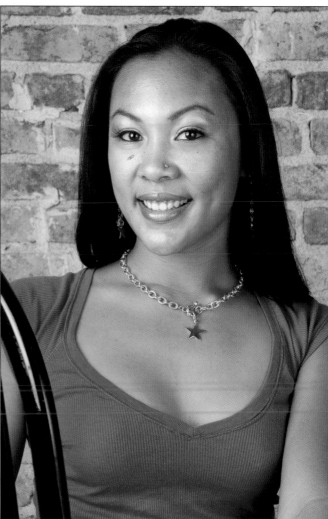

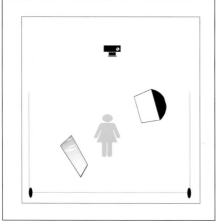
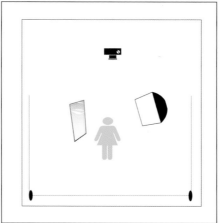

Left—The first diagram shows a common, but possibly ineffective, position for a reflector. The reflector was positioned behind Riesey for this image. There is an imaginary straight line connecting the softbox to Riesey to the reflector. This placement would throw some light back at your subject's hair but would not fill the shadows created by the softbox. It does, however, create a subtle but nice highlight on the back of her cheek when her hair is behind her, and it is perfect if this is the look you are after. **Right**—The second image and diagram shows a more effective placement of a reflector. Place the back edge of your reflector at your subject's cheek (just like feathering the softbox) and push the front edge forward (toward the softbox). The reflector and the softbox are almost at a right angle to Riesey and create a similar angle for the light to bounce into the shadows. You'll see the shadows lighten when the angle is correct.

distance that you place the reflector from your subject will determine how much light fills the shadows. Reflectors placed close to your subject will bounce more light into the shadows.

The impact that the size of your main light source has on your image was demonstrated in chapter 2. Quality of light issues are important when choosing a hair light too. A bigger light will provide a softer and more spread out high-

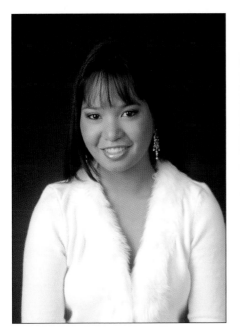

This series of images of Teresa Bringas shows the effect of moving a reflector farther from your subject. The distance from the silver reflector to Teresa was approximately doubled each time. The light reaching the reflector and bouncing back decreases dramatically as the reflector is moved because of the inverse-square law (see page 60).

These three images of Mapuana Makia show the effects of three different sized hair/edge lights. The highlights became broader and softer as the light source increased in size. The first image used a spotlight with a 20-degree grid; the second one featured a small StripDome, and a medium StripDome provided the light for the third image. The exposures for all three were kept consistent for demonstration purposes, but smaller light sources may appear brighter than large ones (at the same angle and distance), so I will usually bump up the exposure a little for the StripDomes.

Facing page image and above diagram—Racquel needed a corporate type headshot to send to prospective employers. To light her portrait, we used a 30x40-inch softbox metered at f8^7/$_{10}$. A strobe fitted with a 20-degree grid was metered at f5.6^7/$_{10}$, adding 1/$_2$ of a stop to the exposure of her face. The combination of main and fill light equaled f11^2/$_{10}$. The image was exposed at f11. The hairlight was a gridspot exposed for f11^2/$_{10}$.

light for your hair or edge light. The final commercial headshot of Mapuana described earlier in this chapter was created using a spotlight with a 20-degree grid. The spotlight provided a sharp and well-defined highlight in her hair. There are many times that I prefer a larger, softer hair light. Beauty headshots or images where I want some light to spill onto my subject's cheek are examples of when I want softer highlights. Small softboxes or StripDomes are perfect tools for the job.

Executive Portraits. Corporate headshots are a distinct subcategory of general portraiture. The impact needs to be immediate. The look can be friendly or stern, but the image needs to imply that this person is in control. The lighting needs to draw you into the executive's face, but it also needs to keep your eye

The image of Gene shows that the effect works with a more casual look too. A 1/$_4$ Color Temperature Blue gel was added to the hair light to raise the color temperature of that light. The slight blue cast adds more visual contrast to the image. We'll see a few more variations on corporate lighting a little later.

moving around the image. Funky and dramatic lighting can work for executives, but variations of the four-light commercial headshot lighting scheme are good starting points for most corporate headshots. To review, a 30x40-inch softbox is used as the main light, and a strobe fitted with a 20-degree grid acts as a fill light. A strobe with a grid is used for a hair light. The backdrop can be lit as well, depending on what you want to do. I'll play more with the color temperature of the hair/edge light in an executive portrait than I might in a commercial headshot, but the lighting is generally similar.

FASHION AND GLAMOUR

Softboxes have a multitude of uses in fashion and glamour photography. Fashion photography, almost by definition, gives the photographer carte blanche to play with every tool in his or her arsenal. Softboxes of all sizes can be used as main lights and/or fill lights or accent lights for other sources of illumination. The effects of different sized softboxes, how they are used, and the interplay with other lights create a playground filled with options for the fashion photographer. First, we'll look at softboxes used as main lights in fashion photography.

The extra-large (40x60-inch) softbox is a very effective light for shooting catalog-type fashion images where the outfits are photographed against a white backdrop. This is especially true when the garments are white because smaller light sources produce more contrast, and it can be difficult to maintain the whites with a light source that has a lot of contrast. It is an effective light source for these purposes because it is an extremely broad and forgiving light and can accommodate many styles of clothing. However, it can be a little on the "flat"

Facing page image and above diagram—The image of Diane Lang could be used in any commercial clothing catalog. The diagram for this series shows the setup for the shot of Diane.

The softbox was positioned at camera left for the images of Callie and Ana. Ashley designed the hair and makeup for Callie.

The combination of a very large light source and a white backdrop is perfect for many catalog-type commercial fashion shoots. The images of Ana, Callie, and Diane could have been shot on the same day. The lighting is even and clean and shows the wardrobe—exactly what this type of client would want! A $1/2$ stop of fill light adds the needed contrast to keep the images from becoming too flat.

Left—The image of Ana Tsukada shows the versatility of the technique for shooting white on white on white. (*Note:* The upper portions of the backdrop were overexposed to record as white without detail, and her white skirt was slightly underexposed to maintain the highlights, but the area of the white backdrop on the floor directly behind Ana needed a little work. You need to have your model far enough from the white backdrop to avoid flare, so the reflected light values from the backdrop drop off by the time it reaches your subject. As a result, the white floor recorded as a dingy gray. A Curves adjustment layer and a layer mask "fixed" the problem.)

Right—The image of Callie also shows that the same lighting can be used for a high-fashion headshot too.

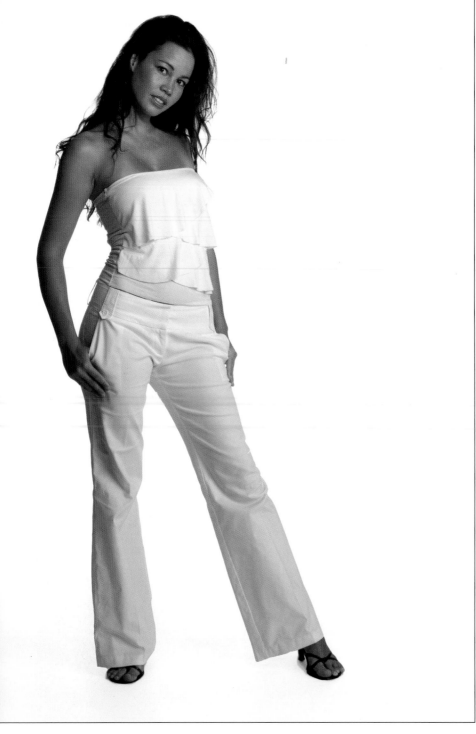

The 40x60-inch softbox with a fill light set to add $1/2$ stop is beautiful when shooting white on white. It's set so the main light is metered at f5.6$^7/_{10}$ and the fill light is f5.6$^7/_{10}$. Forget the fractions for a minute: the fill light is 1 stop less than the main light, so it adds $1/2$ of a stop to the exposure on Sanna's face. Now, returning to the fractions, f8$^7/_{10}$ plus $1/2$ a stop is f11$^2/_{10}$ (trust me)! I shoot these images at f11, so I underexpose the white garments by $^3/_{10}$ of a stop and slightly overexpose her face by $^2/_{10}$ of a stop. This keeps the exposures within the limits of digital/transparency film capture and maintains the highlights in her clothes.

side for my taste (not to mention the print press)! I use the 40x60-inch with a spotlight fill for many of my commercial fashion shots.

Shooting against white backdrops can be tricky because they need to be lit to go white without detail. You will need to throw more light on the white backdrop than what your camera is set for. For digital and transparency work I usually overexpose the white by a stop. Now, white is highly reflective, so all that light is bouncing right back at your lens! The inverse square law comes into play. Briefly stated, the inverse square law says that the intensity of light will drop off rapidly as the subject moves from the light source. The light right at the backdrop is a full stop brighter than your working aperture and is a recipe for a flared

disaster. However, the same light that reaches the back of your model will diminish rapidly simply by moving your subject away from the backdrop. There is a way to determine how far the model should be from the backdrop to avoid flare. (Flare is created when more light enters your lens from behind or along side of your lens than your aperture is set for on your camera.) No, you don't have to do any complicated mathematics to figure it out. Take your handheld incident light meter and hold it right behind your subject. Point the dome at the backdrop and take a meter reading. You are good to shoot when the reading is equal to or less than your working aperture. However, I am much more comfortable when this reading is less than what I have set on my camera.

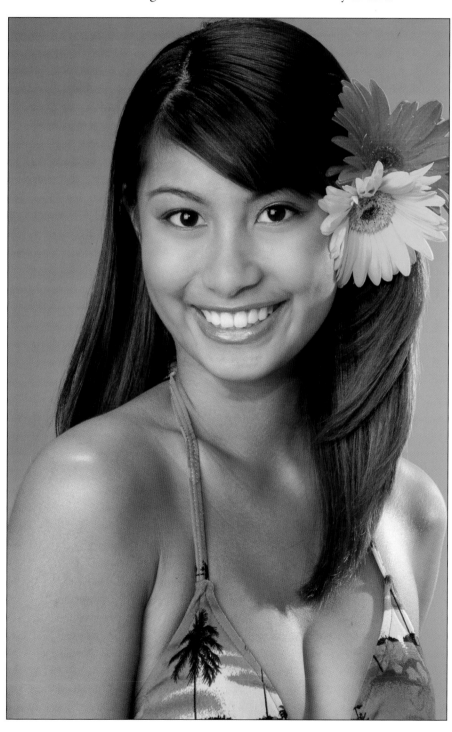

The main difference between this image of Ruth and the ones that preceded it (aside from the blue backdrop) was the hair light. A medium StripDome was placed on a boom and positioned overhead. Using StripDomes and softboxes as overhead hair lights can be tricky: position the light so the front edge of the box light is just above the upper hairline. Placing your subject right under the center of the box will likely create an unwanted highlight on the bridge of your subject's nose.

The white sweep can also be hard to light evenly in a full-length portrait: it tends to go gray. I'll generally touch it up in Photoshop after the shoot.

The larger softboxes need not be used solely with white outfits or white backdrops. Bright colors can be accentuated with this lighting scheme too. Ruthchelle Melchor (previous page) re-created an island scene in the studio!

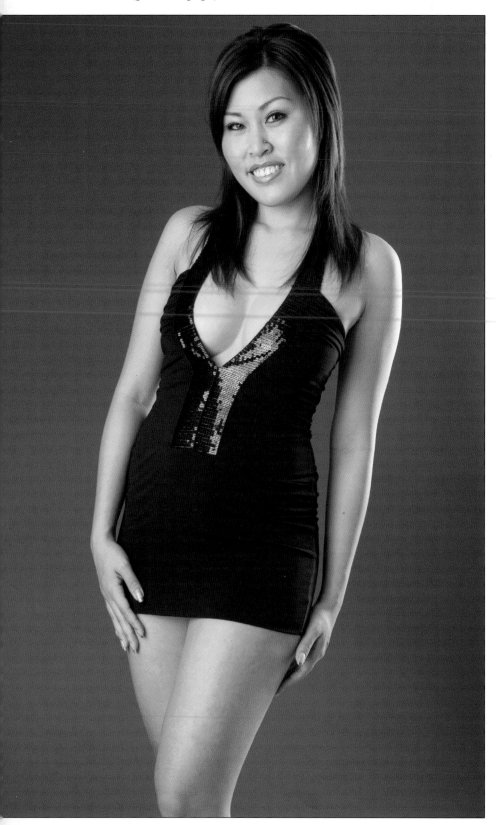

Left image and above diagram—On rare occasions I use the 40x60-inch softbox as a sole light source. Marissa was lit with the "big box" for a simple, effective fashion image. I don't recall whether I used a reflector (I don't see a catchlight from a reflector in her eyes, so probably not), but a StripDome was used to add a hair and rim light and to provide some contrast. **Facing page**—The 30x40-inch softbox was used as the only main light for this image of Jenny Weinman. I would normally use a spotlight fill to add a "pop" to my subject's face. I added $1/3$ of a stop to the whole image to gain that extra "pop"— and almost lost the detail in Jenny's shirt in the process! The exposure range of digital capture is seriously limited! I took advantage of the RAW conversion program to open the image again at $1/2$ stop underexposed and used a layer mask to sandwich the two images. The technique used is described in detail in chapter 5. We also had to closely monitor the hair light used because it was spilling onto her shirt and causing problems. We eventually went with a spotlight with a 10-degree grid and skimmed the light so it just grazed her head. An amber gel was taped over the strobe to produce the warmed-toned hair light.

Mistakes are fine, as long as you learn from them. Here is the same setup that required some additional postproduction work (minus the hairlight). This time the image was metered and exposed at f11. There was no problem holding the details in Stephanie Usita's outfit.

Medium to large softboxes are natural choices when lighting a group portrait. The light emanating from these tools is beautiful, with a contrast level that is soft and fairly easy to control. This image was provided by my good friend Stan Cox II. One of Stan's many studio techniques involves the use of the 30x40-inch softbox for his main (or "key" light) for his fine-art portraits. A fill light is fired through a scrim to soften the shadows. The hair lights for this image were smaller softboxes. Stan added a slight blur and dark vignette along with a slight contrast Curves adjustment in postproduction. The beauty of photography lies in the vision of each individual photographer and how he or she uses the tools described in this book. Stan produces beautiful work, but his style is distinctly different from mine.

There may be applications for using an even larger softbox for a main light, but right now we'll address using a smaller box. The 30x40-inch softbox is the most versatile light modifier in my studio. It is my first choice for most of my general work—as long as it doesn't involve a white-on-white situation! The box produces a beautifully soft light that still has a good deal of contrast. White garments can be photographed with this softbox, but be aware of your highlight details when shooting digital. This size softbox can be used as the only main light because of the increased contrast, or in conjunction with other lights.

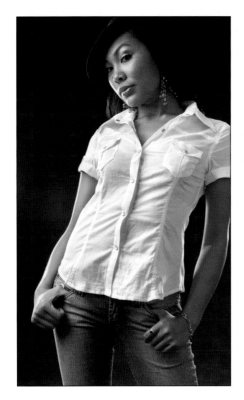

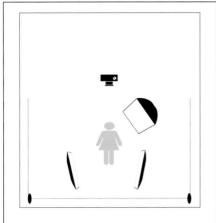

Left image and diagram—Make no mistake about it: whites are extremely difficult to photograph with digital capture. We wanted to add some punch to the casual fashions worn by Riesey so we set the 30x40-inch softbox in an almost side lighting position (almost 90 degrees camera left) and added two medium StripDomes as hair and rim lights. We were extremely careful with the exposure of this image and double checked the exposure where more than one light lit the same section of her shirt. We still lost detail in the whites and used the RAW conversion technique described in chapter 5 to save them. The image would have probably been lost if it were captured as a JPEG. **Right**—Corporate headshots using the 30x40-inch softbox as the main light in a three- to four-light setup were shown on pages 56 and 57. In those shoots, a spotlight was used as a fill in a "typical" corporate setup. Here, the softbox is used in isolation to create a dramatic public relations image of photographer Paul Landry. Just as in the last photograph of Riesey, the light is positioned almost at a 90-degree angle to exaggerate the shadows. A spotlight hair light keeps the left side of Paul from blending into the dark backdrop. Corporate images can have an "edge" to them too!

The 30x40-inch softbox can be very effectively used as a main light for commercial fashions in much the same way as its larger counterpart. The smaller version has a bit more "punch" to it. One of my favorite commercial fashion lighting schemes was demonstrated in detail on pages 52–53—it's my four-light commercial headshot lighting!

Complex lighting schemes for glamour photographs will be described shortly. Sometimes, however, less is more.

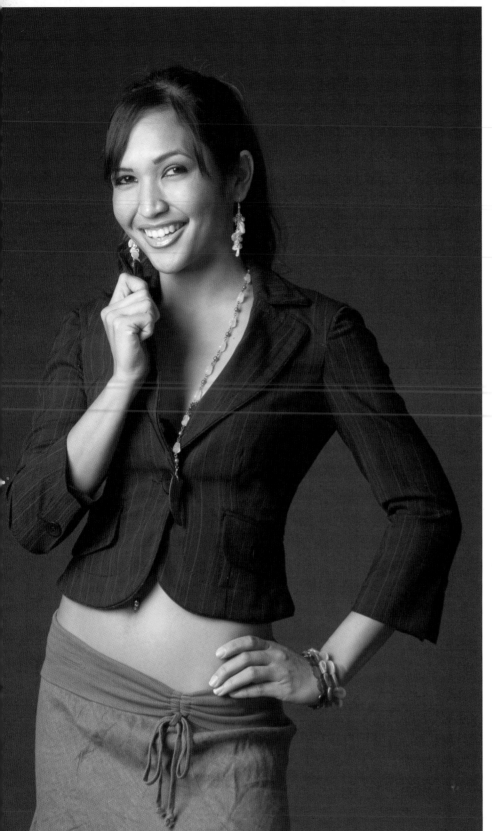

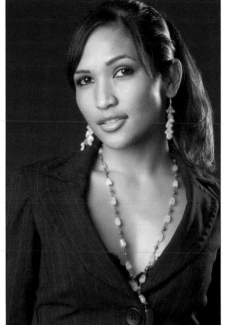

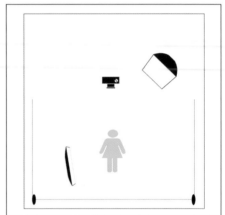

Above image and diagram—The addition of a small StripDome for a hair light turns this lighting scheme and outfit into an elegant portrait. **Facing page**—The "four-light commercial headshot" lighting scheme also works as a "four-light commercial fashion" setup too! Christine was lit with a 30x40-inch softbox as a main light with a spotlight fitted with a 20-degree grid for a fill. Her hair and the backdrop were lit with gridspots as well. An amber gel was placed over the hair light. See the diagram on page 53.

The 30x40-inch softbox can also be effective as a single light source for dramatic fashion images. Tishanna's earth-toned fashions work well against the rust-colored backdrop—the backdrop is actually red, but without a separate light to illuminate it, it takes on the darker hue, which works for this image. The softbox is large enough to provide wraparound lighting that shows detail in the shadow side of Tishanna's jacket and lights the accessories on her wrist.

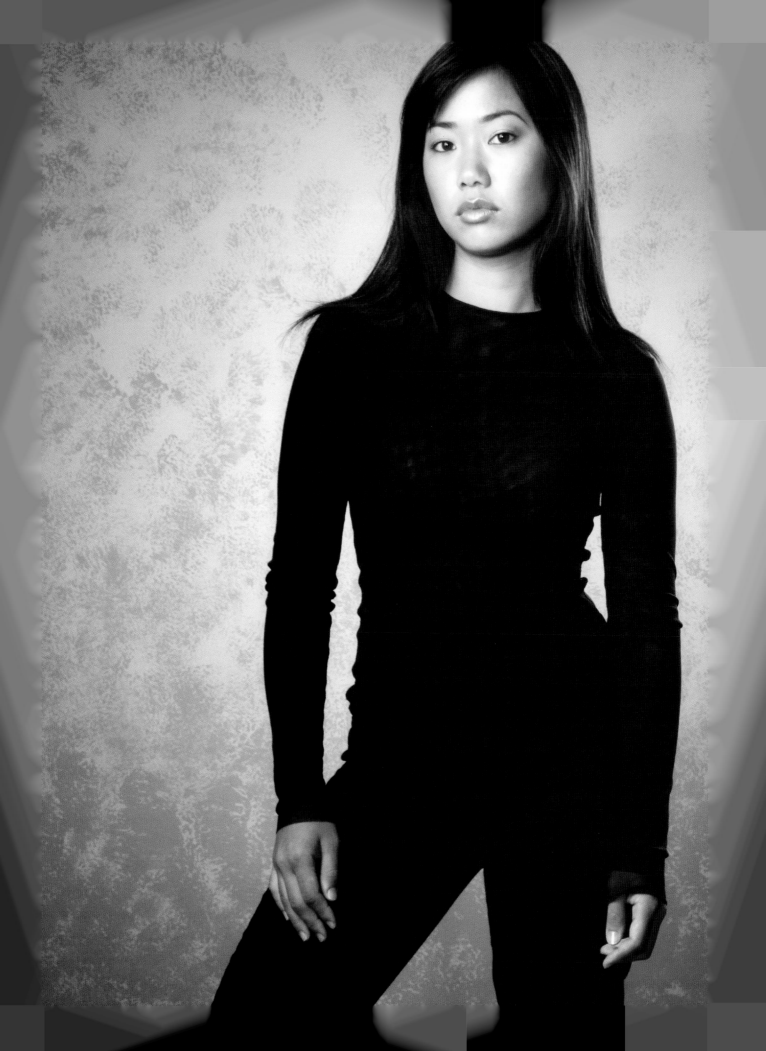

The beautiful and intimate portrait of Mapuana Makia (below) was created with one 30x40-inch softbox for the main light. A spotlight lit her hair, and a medium StripDome provided an edge light for shots when she was lying down.

The smaller softboxes or StripDomes can be quite effective as main lights for fashion images. The medium StripDome is a surprisingly soft light for its size. However, the falloff is more extreme than its larger counterparts, so the light is more focused.

The small StripDome is a go-to tool for creating truly dramatic fashion or glamour images. The light is much harsher than larger softboxes but doesn't

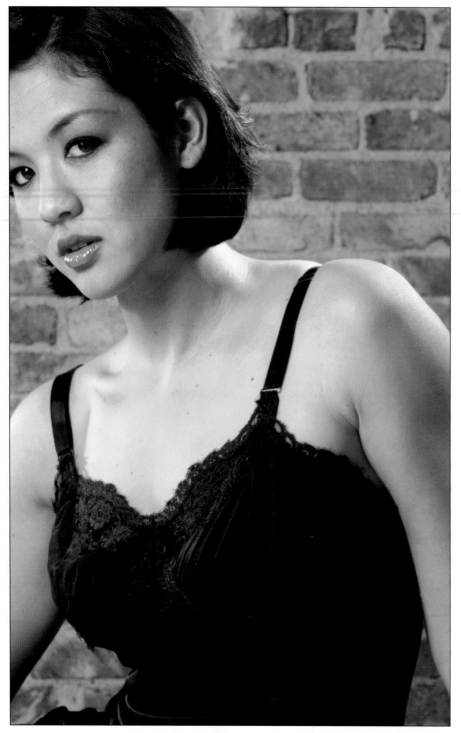

Left image and above diagram—Less light was more for this image of Mapuana Makia. Simple lighting increased the intimacy of this photograph. Don't be afraid to try different cropping styles either. The close and off-center cropping of this image also works to add some mystery to the image.

Facing page image and above diagram—Dramatic lighting opens the door for more dramatic angles and poses. The light on Angella's face from the medium StripDome is still soft and pretty, but the rapid falloff and angle of view makes for an effective fashion image. A spotlight with a 20-degree grid was used in conjunction with the StripDome to give this image a little more "kick."

produce the extreme specular highlights that spotlights create. The falloff of light is quite severe, so they are quite effective when you want to highlight a certain part of the wardrobe—a particular shirt or jacket, for example, or perhaps accessories like jewelry.

Small StripDomes can work in isolation to create a high-fashion look. A single small StripDome was used to create the elegant image of Aiko shown on page 37. Here, we used the same technique with the addition of a second small StripDome to add some punch to a basic denim shot.

Two small StripDomes were used to create a stylish take on blue jeans. The main light was a single small StripDome, and a second StripDome provided the light that "lifted" Naomye off of the backdrop.

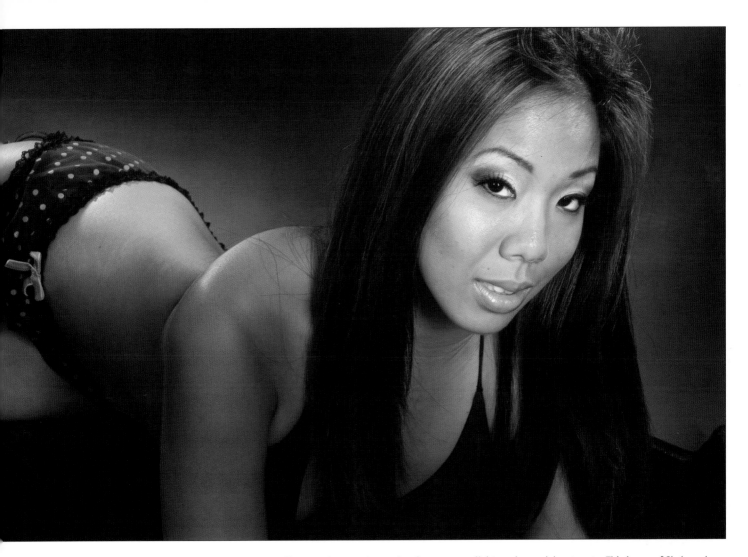

Glamour photography can involve numerous lights and very elaborate sets. This image of Sheleen, how-ever, was actually a fairly simple setup. The main light is a small StripDome. A larger Halo was backed up and used for an overall fill light. A spotlight with a 40-degree grid was used as a hair light, and another spotlight with a 20-degree grid lit Sheleen's legs and hips. The spotlights had an amber gel over them to add a little warmth to the lights. A technique known as the "cookie cutter" was added in postproduction to finish the image. (I learned the "cookie cutter" technique from Eddie Tapp. It will be described on page 87.)

CHAPTER FOUR

COMBINING LIGHT SOURCES

*T*he true creativity—and fun—involved with lighting comes when you start combining light sources and using different sized lights to create a specific image. Softboxes and/or Strip-Domes can still be the main lights in a multi-light setup—or they can play the role of a fill light, providing the overall ambient tone for other smaller lights to accentuate.

The "small" light in these photos of Midori Every (below) was actually a medium-sized umbrella. The large light was a 40x60-inch softbox that was used as a fill source. Two spotlights illuminated Midori's hair and provided a rim light for the ¾ body shot.

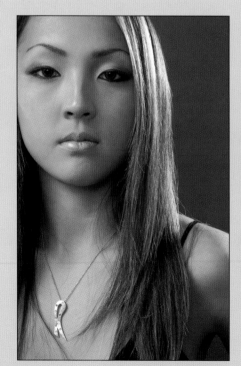
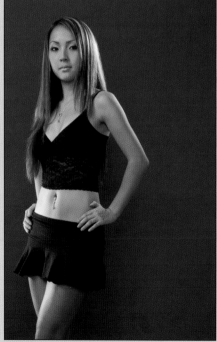

The umbrella was set up almost in a split lighting position for these shots of Midori Every. The 40x60-inch softbox was used as a fill, set at 1 stop less than the umbrella, to keep the shadows from going too dark.

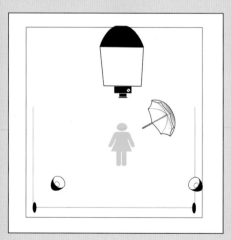

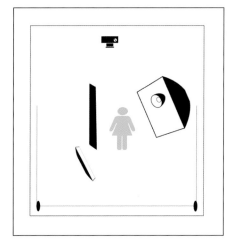

The extreme difference in size between a 40x60-inch softbox and a spotlight fitted with a 20-degree grid creates a very dramatic headshot for model Jenny Koontz and hair and makeup artist Elaine Saunders. Both main lights were set to provide close to the same exposure. The increased contrast of the small light source dominates the larger, softer light. The small light would overpower the large light and look like a harsh on-camera flash if it were placed in a fill light position.

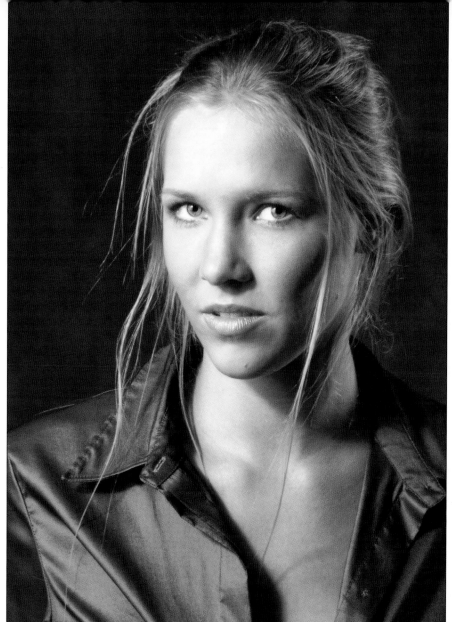

One of my favorite techniques is using a softer light source in conjunction with a smaller, harsher light source. This technique is called a hard/soft lighting scheme. Some of the images that you have seen so far have used a small spotlight as a fill light. Technically this setup would fall under this category, but the effect is quite different when the lights are lined up along the same axis. The requirements for what is the hard light or soft light are relative—the soft light could be a 40x60-inch softbox, and the hard light could be a small StripDome. Alternatively, the soft light could be a small StripDome, and the hard light could be a spotlight. The effects will vary dramatically depending upon your choices.

The 30x40-inch softbox in conjunction with a spotlight is also a very effective combination for this technique. The effect will vary depending upon the relative intensity of the two lights. The two images of Brooke Tanaka on pages 74 and 75 show the same lighting with different relative exposures.

Removing the outside bevel of the softbox creates a large, but still harsh, light that is very effective for glamour photographs (see page 33). Adding a spotlight increases the impact of the harsh lighting scheme.

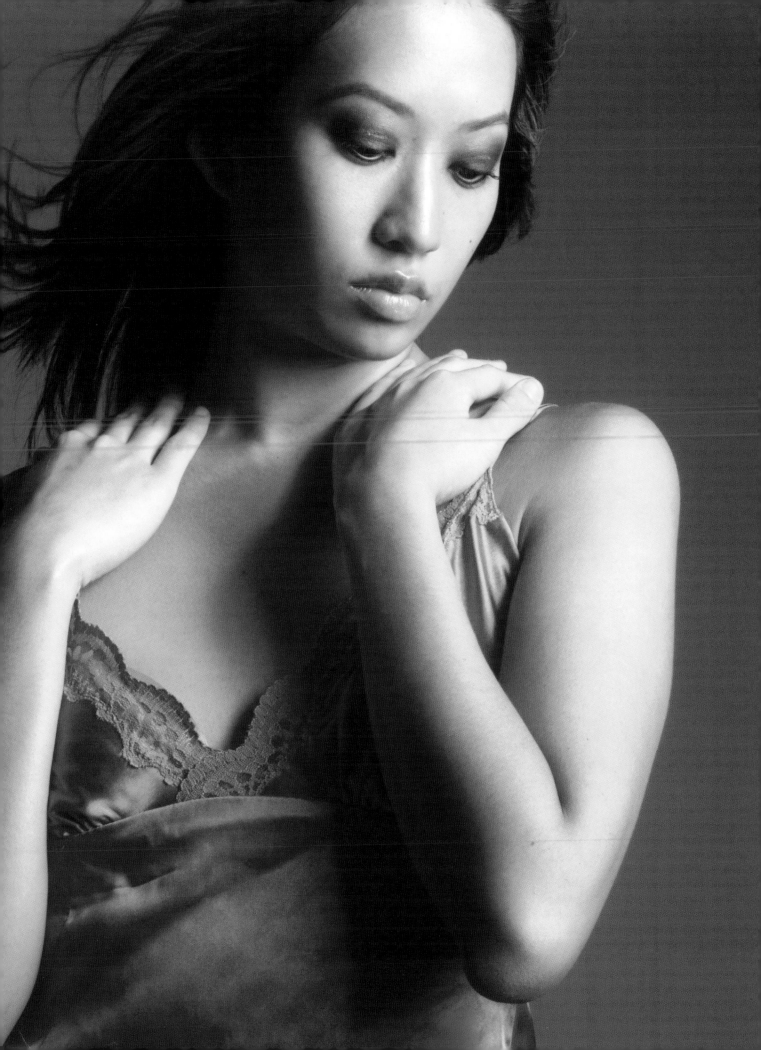

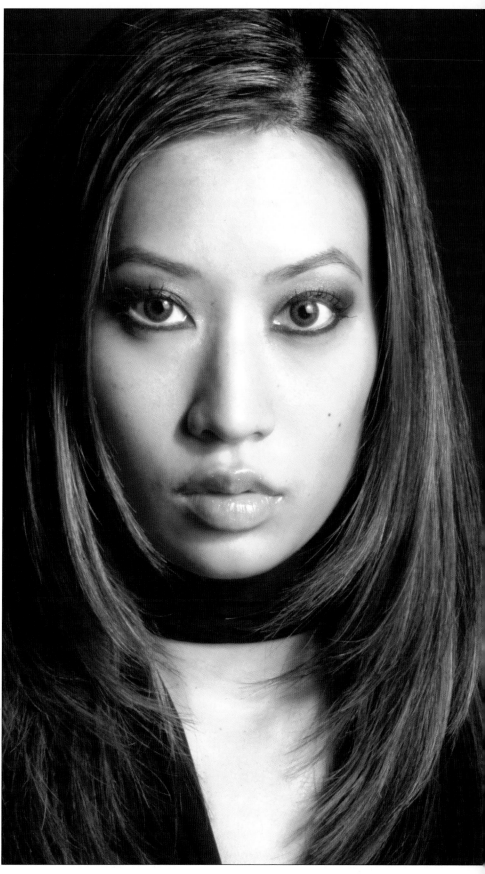

Facing page—This image shows the hard/soft technique where the spotlight was set 1 stop less than the 30x40-inch softbox. The impact is quite different than the earlier examples of using a spotlight with 1 stop of fill for the same sized softbox (Mapuana, page 53). The impact of the fill here is more dramatic even though the exposure is the same. In this case, the main light was set at f8$^7/_{10}$, and the fill light was set at f5.6$^7/_{10}$. The overall exposure was f11$^2/_{10}$, and the camera was set for f11. **Right image and above diagram—**The image shows the effect when both lights were set at f8$^5/_{10}$. The overall exposure was f11$^5/_{10}$, but the camera was still set at f11. Therefore, Brooke's face was overexposed by $^1/_2$ a stop. **Below—**The main light for this image of Naomye Leiza was a 30x40-inch softbox with the outside bevel removed. A spotlight fitted with a 20-degree grid was placed along the same axis as the softbox for a harsher version of the hard/soft technique. A small StripDome was used as a hair and rim light. The blue backdrop was lit with a spotlight with a dark-blue gel to maintain the color of the sweep. A colored backdrop will lose some of its saturation if white light is thrown on it; find a similar colored gel to keep the rich colors of the backdrop.

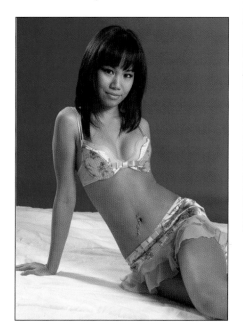

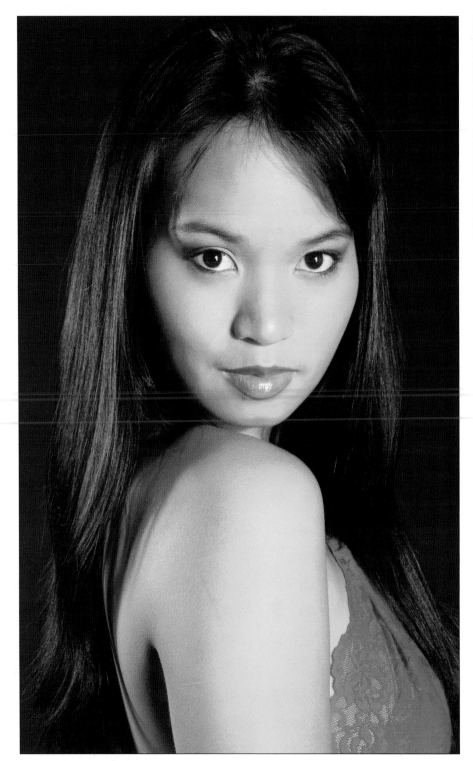

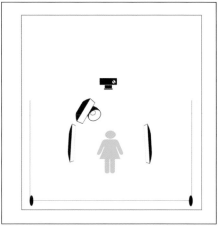

The dramatic image of Kathryn (facing page) was created by combining a spotlight fitted with a 20-degree grid with a small StripDome. Both lights provide a great deal of contrast, but the StripDome is still the softer of the two lights. A spotlight with a 40-degree grid was used as a hair light. Your choice of hair lights can change the mood of the photograph too. The general lighting scheme was the same for the glamorous portrait of Teresa (left), but the use of medium Strip-Domes as subtle hair lights sets the stage for a very different image. The spotlight was moved closer to the StripDome for the image of Teresa as well.

The effect can be very interesting when both lights are fairly small and harsh. As we have seen, small StripDomes create a harsh quality of light. However, it is relatively soft compared to a spotlight fitted with a grid. The combination of lights can be used to create a very dramatic portrait or fashion image. The images of Kathryn and Teresa Bringas were created by placing a spotlight with a 20-degree grid next to a small StripDome. Both lights have a great deal of contrast, so there was no need to overexpose the image to create the "snap." In these cases, the spotlight was exposed at 1 stop less than the StripDome.

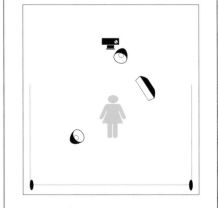

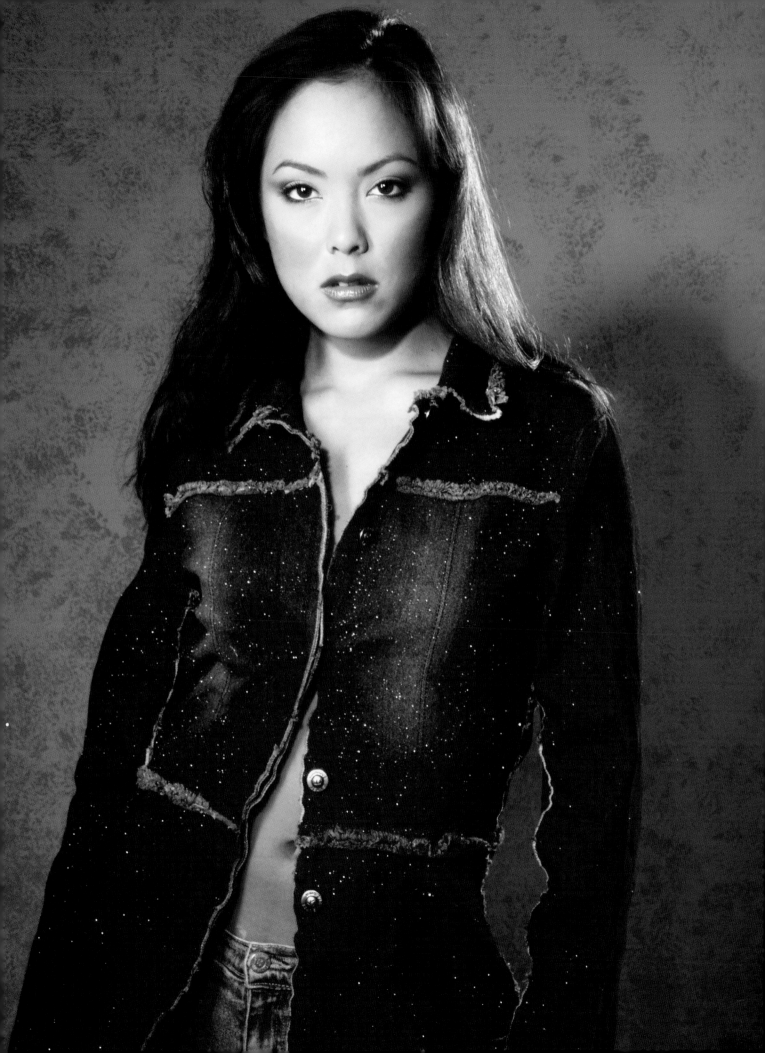

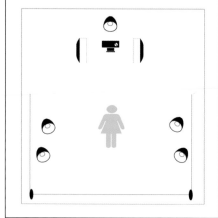

The striking image of Ana Tsukada was created with two small StripDomes and a spotlight acting as co-main lights. The StripDomes were placed on either side of the camera, as close to the camera as possible, and the spotlight that was fitted with a 10-degree grid was placed directly behind the camera. Each light was metered at f8 for an overall exposure of f11^3/$_{10}$. The white seamless backdrop was lit with four spotlights each metered at f8 for an overall exposure in the middle of the sweep of f11^9/$_{10}$. The image was captured at f11—or 1/$_3$ of a stop overexposed—just about at the point where we begin to lose data with digital capture.

Variations of the lighting used to create the image of Ana on page 78 were used in the photographs of Teresa Bringas and Marie Wourms below. Small StripDomes were placed on either side of Teresa, creating two side lights of equal power. The spotlight was set at 1 stop less than either of the StripDomes. Medium StripDomes and a softbox were used in the photograph of Marie. Great care was taken when positioning the fill lights to avoid a reflection in the window.

Medium StripDomes were set as co-main lights for an elaborate setup that resulted in a fashion headshot of Angella. A 30x40-inch softbox and a spotlight with a 30-degree grid combined for a hard/soft fill light in this configuration. A spotlight covered with a red gel lit the backdrop and provided an interesting spill of red light onto Angella's hair.

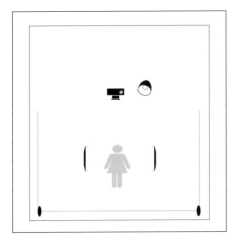 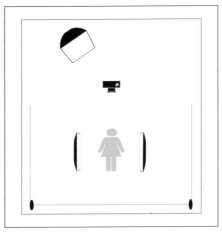 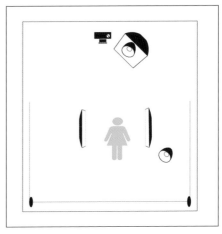

Left image and diagram—Side lighting can create very dramatic images. Sometimes the shadows created by the two lights can be too dark for the desired effect. A spotlight fitted with a grid can provide the necessary light to fill the shadows while maintaining the drama of the co-main lights. **Center image and diagram**—A variation of the theme for the image of Teresa has two medium StripDomes set as co-main lights and a 30x40-inch softbox for a fill. All of the lights were larger in this setup, and the StripDomes are angled in toward Marie Wourms more than the small StripDomes were for Teresa. The effect is similar, but softer, in the image of Marie. Teresa pulled double duty for this series: she was also the hair and makeup artist for the shoot with Marie. **Right image and diagram**—The larger softbox and spotlight combined for an exposure of f8⁴/₁₀ in this image. The two StripDomes were actually the main lights, reading f11¹/₁₀ each. The combined light falling on Angie's face was f11⁷/₁₀. The image was overexposed a little at f13 (11³/₁₀).

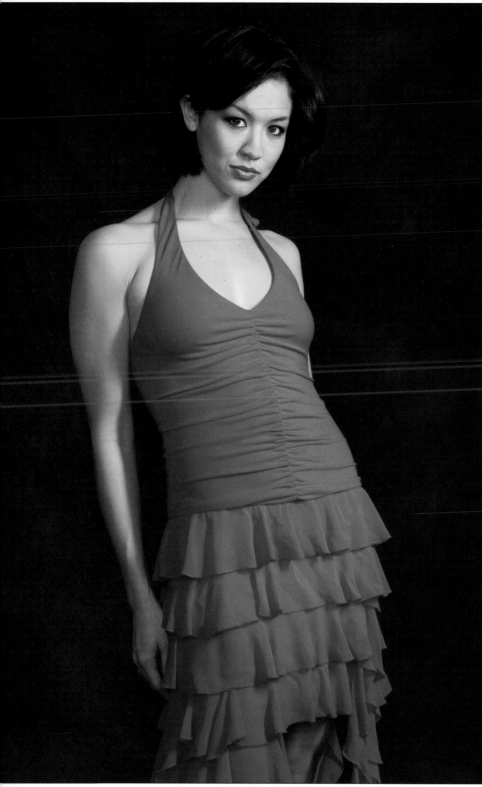

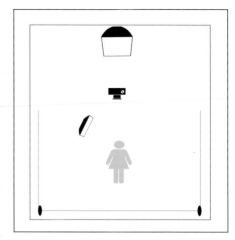

Left image and above diagram—Too much detail would have been lost in the ripples of Mapuana's dress if the small StripDome had been used in isolation. A 30x40-inch LiteDome softbox was positioned behind the camera and was set at 1 stop less than the smaller main light. The impact of the image comes from the small light (and Mapuana!), and the large fill keeps the image from going too dark by her knees.

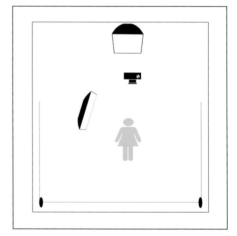

Facing page image and above diagram—The setup for Marie's take on casual fashions was the same except that the medium StripDome was used in place of the smaller version. The lighting is a little more "edgy" than usual for this type of outfit, but it doesn't overpower the laid-back feel of the clothing. Notice that Marie is posed opposite the main light, throwing the right side of her face in shadow. This technique, while unnecessary for Marie, can be very effective in hiding flaws in your subject's skin. Hair and makeup services were provided by Teresa Bringas.

The larger light does not always need to be the main light in these setups. Small lights are striking tools when used as main lights. Small lights work partially because the light falls off and dissipates quickly. Sometimes the falloff can be too much and you lose too much detail in the shadows. Large light sources can be used as fill sources to maintain enough detail without changing the impact of the smaller lights. The fashion images of Mapuana Makia, Marie Wourms,

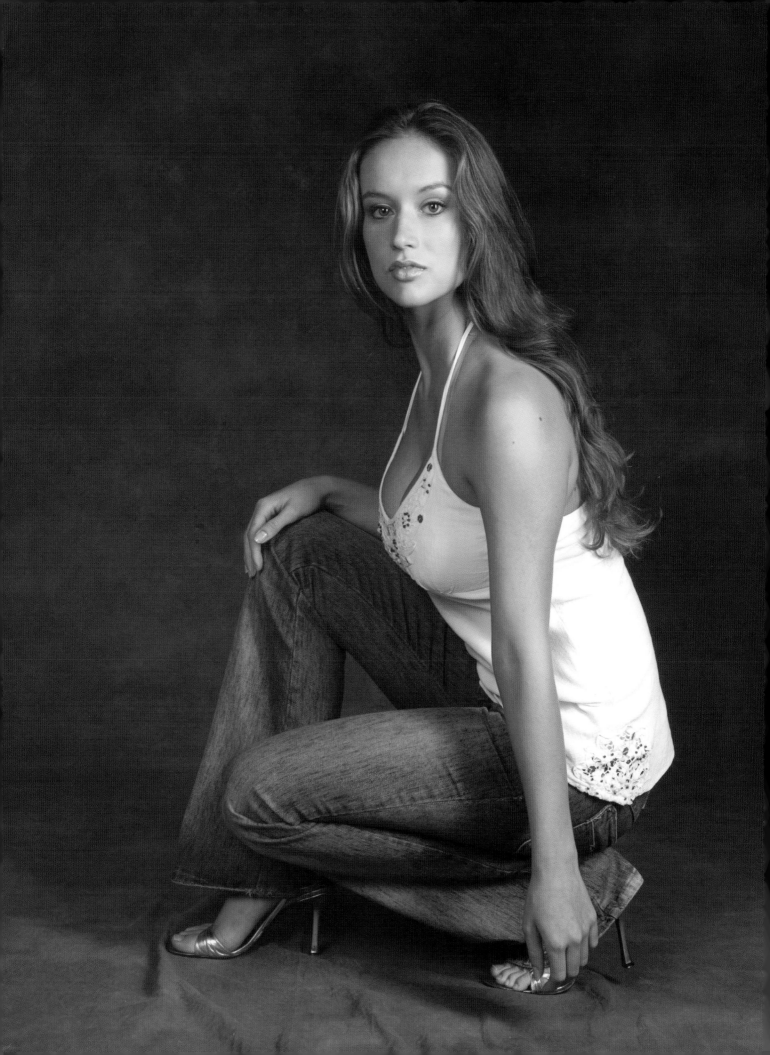

Audrey Vasquez, and Callie were created with larger light sources as a fill light and smaller softboxes providing the main illumination. The fill light for these images was the 30x40-inch softbox. The main light for the image of Mapuana was a small StripDome, while a hard/soft combination of a medium StripDome and spotlight was used as the main illumination for the portrait of Audrey. A 40x60-inch softbox provided the fill and a medium StripDome was the main light for the photograph of Callie.

We have looked at the use and combination of small light sources to create fashion images. However, a combination of larger lights can be used for fashion images too. A 30x40-inch softbox, two Halos, and a small StripDome were used as main lights to blanket Ashley with light for these stylish fashion photographs.

Larger fill lights provide an overall ambient feel to the fashion and glamour images of Audrey and Callie but do not affect the feel of the images. The smaller lights define the look of the respective photographs. The photograph of Callie (right) was overexposed by about $4/10$ of a stop, but it works—primarily because there was no white in the scene and no extremely small lights creating harsh specular highlights. Ashley designed the hair and makeup for Callie. The image of Audrey (below) was styled by Roshar.

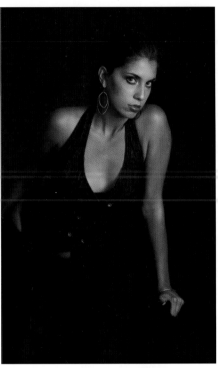

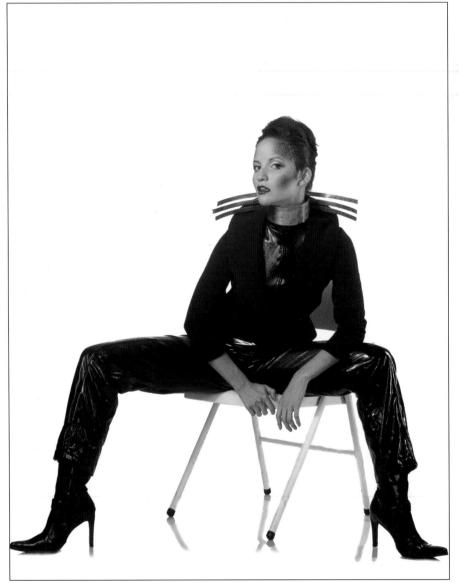

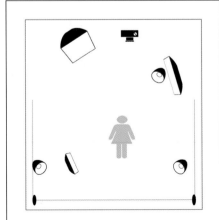

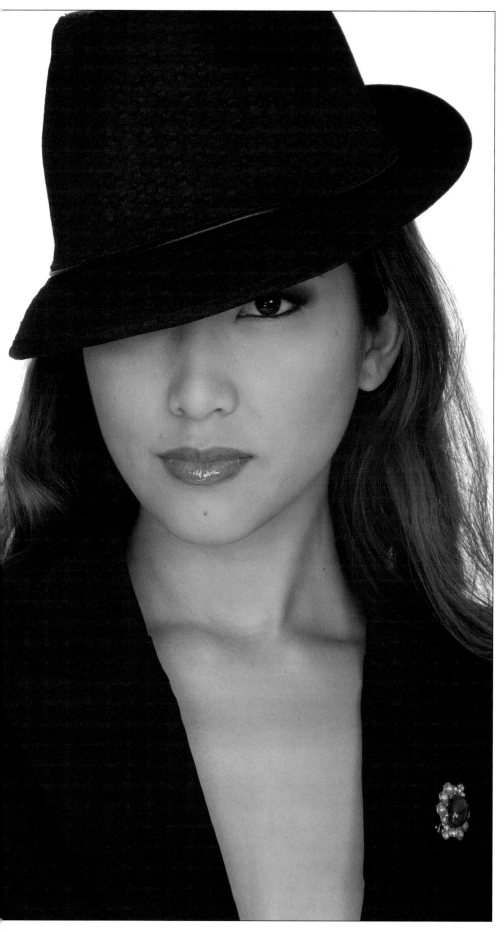

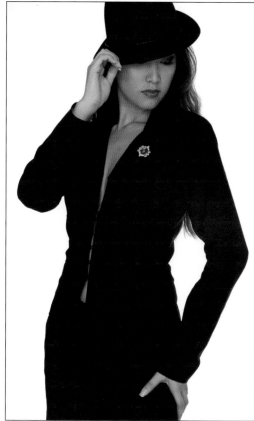

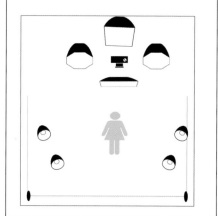

A wall of light was created for these photographs of Ashley. A 30x40-inch softbox was positioned high and above the camera and was angled down. Two Halos were positioned on either side of the camera, and a small StripDome was placed in a horizontal position, lower than the rest of the lights and angled toward Ashley's legs. Each light was metered at f5.6 for an overall exposure of f8^{6}/$_{10}$ at Ashley's face (the StripDome did not yield f5.6 at her face, so the overall exposure did not reach f11). Four lights illuminated the white backdrop. I tried a different way to light the backdrop: I set each individual strobe to f8. I obtained the f-stop that I desired (f16) where all of the lights overlapped, but the individual lights were not bright enough at the corners so I had to adjust the whites in Photoshop. Live and learn!

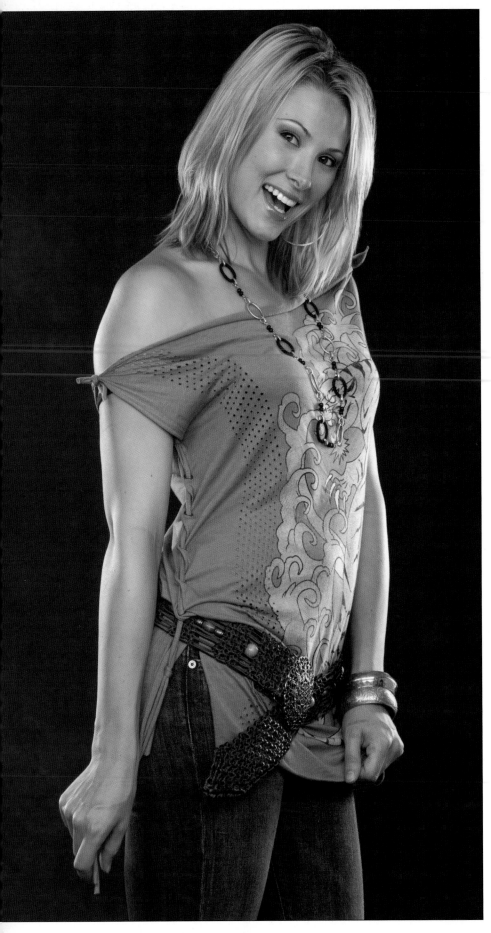

A slight variation of this lighting scheme was used to create these images of Lauren Rush. The Halos and softbox were in the same place, but a medium StripDome was moved behind and to the left of Lauren to provide an edge light to separate her from the dark background. A second medium StripDome was used on the opposite side as another rim light.

GLAMOUR PHOTOGRAPHY

Glamour photography often uses a combination of many lights to create the desired effect. Larger light sources may set the overall ambient feel of the image, but small lights are used to draw attention to various parts of the model's body. The difference in the size of the light sources is relative; greater differences in size between the lights will often create more dramatic effects. The first three images show slight differences in the basic setups but show how the effect can be

The lighting scheme for this image of Apryle has an almost commercial or even a portrait feel to it. The smaller lights are present to add visual interest to the photograph, but they all play a supporting role for the larger main light. Peter Jones styled Apryle's hair and makeup.

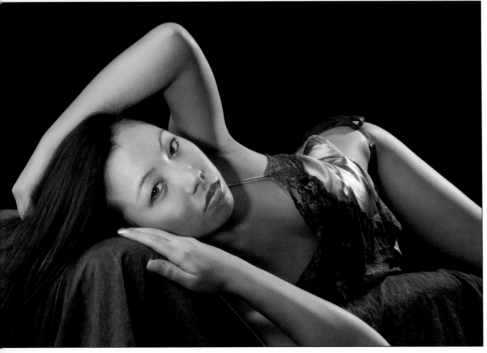

The gridspot is much smaller in this photograph of Angella and is brought along the same axis as the softbox. Both lights were metered at or very close to f11, so essentially the higher contrast from the spotlight makes it appear as though it is the main light here.

PHOTOSHOP TIP: EDDIE TAPP'S "COOKIE CUTTER" TECHNIQUE

One old-school lighting technique was called the "cookie cutter." Photographers would place a gobo (or shield) with different designs cut into it in front of their lights. The different designs would create distinct light patterns throughout the image; the areas of the image that were lit with unobstructed light would be lighter than those areas where the gobo blocked the light. The shadows created by the cookie cutter are the distinctive features in this technique.

Eddie Tapp has devised a way to use a Curves adjustment layer and layer masks to create an infinite number of "cookie cutter" designs. Here, with Eddie's permission, is the basic technique (modify the trick to fit your needs):

1. Retouch or color correct your image if needed.
2. Click on the Adjustment Layer icon at the bottom of the Layers palette and select Curves.
3. The Curves dialog box will open. Make sure that the Curves box is set for the highlights to be in the upper half of the box (use the toggle switch at the bottom of the dialog box if it is not set up in this way).
4. Click the top-right spot on the diagonal line and drag it straight down (you won't get a color shift by using this spot). Pull it down more than halfway down the box. You will now have a very dark image. Click OK.
5. You also have a layer mask to play with! Make sure that the mask is active (the blank box next to the Curves icon in the adjustment layer) and select the Brush tool. Use the Brush tool like you would in any other layer mask: white will reveal the underlying layer, and black will conceal it. Choose a soft brush (or any pattern brush) and paint in the underlying (light) layer wherever you want it and at whatever opacity you desire. If you go too far or don't like the effect, simply change the paint color to black and paint the Curves adjustment back in.

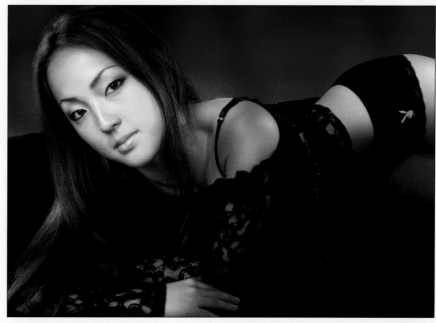

The addition of strategically placed "shadows" using Eddie Tapp's "cookie cutter" technique adds a dramatic impact to the glamour photograph of Midori Every.

changed with different positioning of the lights, different hair lights, and different size lights. The image of Apryle was lit with a 30x40-inch softbox as a main light and a spotlight with a 20-degree grid on camera axis as a fill light. The bed and her body were lit from above with a medium StripDome, taking great care not to lose detail in the white comforter. Her hair was lit with a medium StripDome as well. A spotlight was used with a colored gel to add some interest to the set behind her.

Changing a few of the dimensions to the lighting creates a completely different feel to the photograph of Angella. The backlight was removed, so your at-

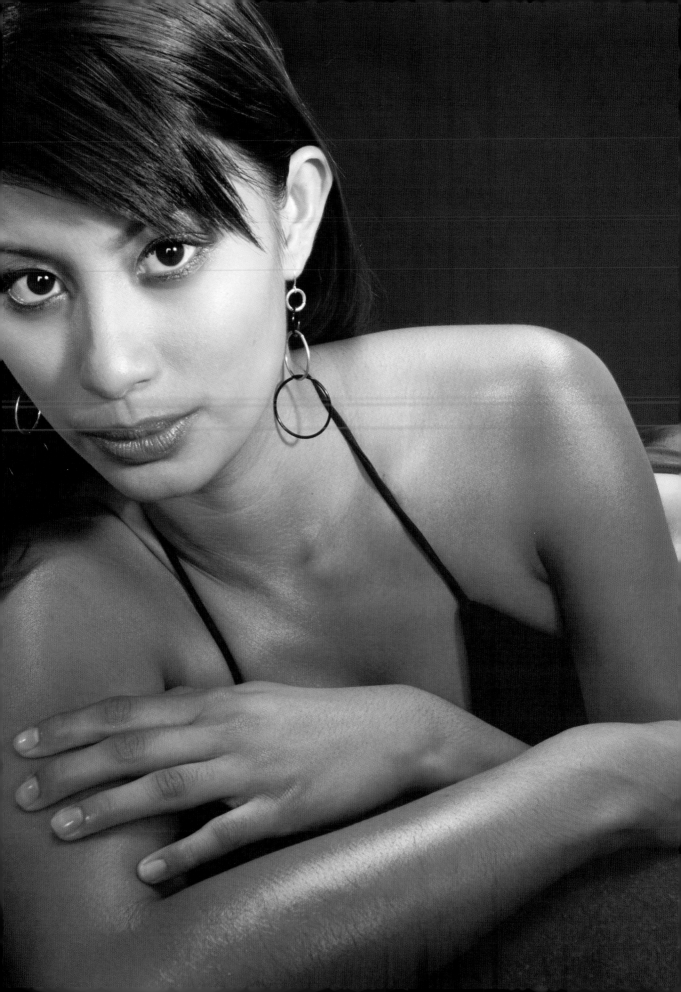

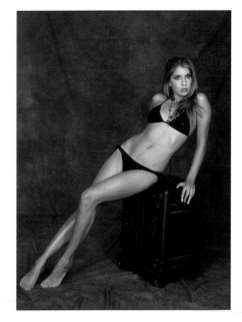

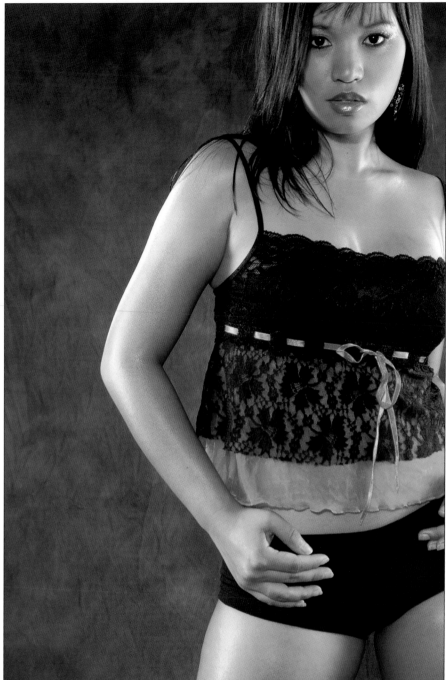

Facing page—This image of Ruthchelle Melchor was created during a commercial session, so I was not able to record the specific data from the shoot. However, the setup was similar to that used to create the photograph of Angella shown on page 86. The major difference was the size of the large light source. The 40x60-inch softbox was set up behind the camera. The effect of the 3-degree gridspot is even more apparent. **Left image and diagram**—Two medium StripDomes were used as co-main lights for this glamour swimsuit image of Callie. Both StripDomes were set at f8. A 40x60-inch softbox was positioned behind the camera and was set at f5.6^6/$_{10}$. The overall exposure was f11^4/$_{10}$. A spotlight hidden behind a flag lit the backdrop at f5.6^4/$_{10}$, adding just enough light to keep the dark backdrop from going black. **Right image and diagram**—The interplay of many different sized lights can be effectively used in glamour photography. Be extremely aware of the exposure where the lights overlap.

tention is now focused primarily on Angie. A spotlight was used in place of a StripDome for a hair light, and the rim light was bumped up. However, the impact of this image comes from the choice and positioning of what became the co-main lights. The spotlight for this image was changed to a 3-degree gridspot and was brought along the same axis as the 30x40-inch softbox. The exposures from the two main lights were almost identical. The main difference in the shot of Ruthchelle on page 88 was the size of the softbox. See the image of Callie and its diagram on page 89.

We have seen that the medium StripDome can be a surprisingly soft main light source. However, it is a small source with a good deal of contrast when compared to a 40x60-inch softbox.

A Halo can be used as the larger, softer fill for glamour shots. The image of Midori Every on page 87 was primarily lit with a small StripDome and spotlight, but the shadows created by the harsher lights were filled with a Halo-style softbox. A second StripDome was used as a hair and rim light.

Seven lights were used to create the image of Teresa Bringas on page 89. There was considerable overlap among the lights, so each light was metered individually and in conjunction with other lights illuminating the same part of the scene. Great care was taken to keep each combination of lights within 1 stop of the working aperture to stay within the exposure latitude of digital capture. Baby oil was applied to Teresa's skin to accentuate the "glamour" feel of the image. However, it also made her skin more reflective, adding to the difficulties involved in controlling the highlights.

A large Photoflex LiteDome was paired with a spotlight with a 40-degree grid as the basis for a hard/soft main light. The softbox was metered at f5.6$^{4/10}$, and the spotlight was exposed at f5.6$^{6/10}$. The combination of these two lights was f8$^{6/10}$, but the spotlight took on the look of a main light because it was so much smaller than the softbox co-main light (it was also slightly stronger than the softbox, adding increased impact to the final look).

Medium StripDomes were used as side lights. Each light was metered at f8$^{8/10}$ or f8$^{9/10}$. Some of the light from the StripDomes also lit Teresa's cheeks, which were illuminated by the co-main lights. The camera was set at f10 (f8$^{2/3}$) to compensate for the extra light on her cheeks and also to slightly overexpose the rim light created by the StripDomes.

A harder edge separation and hair light effect was created by adding spotlights behind Teresa. A 20-degree gridspot was placed on her right, and a 30-degree gridspot lit her hair from her left. The gridspots were metered at f8$^{8/10}$ and f8$^{7/10}$ respectively. There were parts of her body and hair that were illuminated by the StripDomes and spotlights. The light from each of these units was practically the same, so the additive nature of light would dictate that the overlap would be 1 stop more light than each individual light. However, the angles involved were such that there wasn't a direct overlap. Therefore, these light sources were then metered together. The combination on her right was metered at f11$^{4/10}$, and the exposure on Teresa's left was f11$^{6/10}$.

Finally, a backlight with a 40-degree grid illuminated the backdrop. The brownish muslin was slightly underexposed at f8$^{2/10}$.

A Halo can be used as the larger, softer fill for glamour shots.

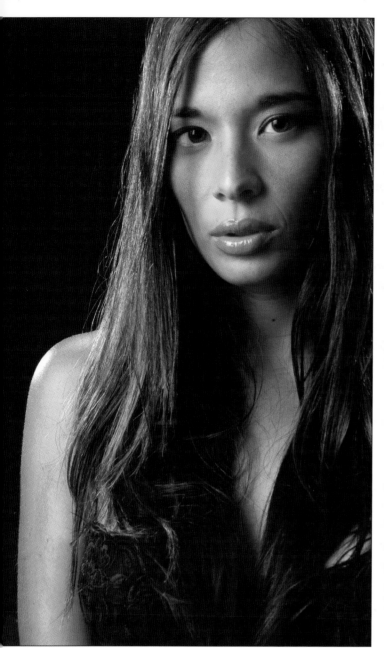

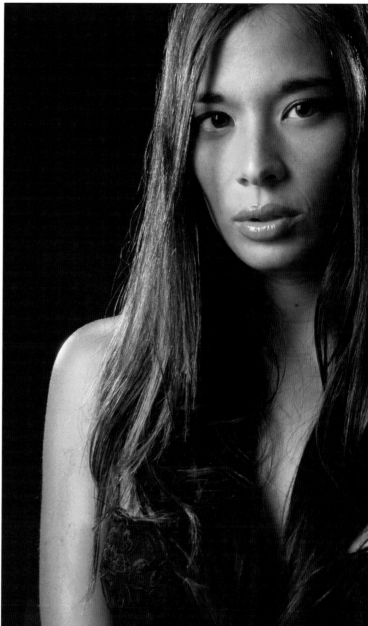

Left—Sometimes you might lose a highlight even when trying your best to keep all of the lights within a narrow exposure range. **Right**—Small areas of your image that have blown-out highlights can be retouched using common Photoshop techniques, but don't rely on these to get you out of major jams. Careful metering is still the best way to go.

The risk of blowing out highlights—even when exercising tight control—is seen in this glamour headshot of Jenny Weinman. The setup is similar to that used to light Tishanna Yabes and Naomye Leiza (see pages 33 and 75). The 30x40-inch softbox was used without the outside bevel for the main light. This time, however, three spotlights were used as rim and hair lights. A spotlight with a 10-degree grid lit the top of Jenny's head (the effect was cropped out in this tight headshot), and two spots with 40-degree grids were placed behind and to either side of her. The main light was set for f11, and the rim lights were set for f8%10 each, but the combination of the two lights sources, the sharp angle of the rim light, the specular nature of spotlights, and the use of baby oil to add

a sheen to Jenny's lovely skin proved too much for the narrow latitude of digital capture.

You cannot use Photoshop to bring back data that does not exist. However, small areas can be retouched to an acceptable degree using some of the more common Photoshop tools. The Healing Brush is an amazing gadget for many retouching jobs, but it still does not handle high-contrast blends very well—*yet!* I started by choosing the Brush tool and setting a low opacity—around 25%. I selected an area close to the blown-out highlight and painted in some skin tones over the white. The white area now looked more like her skin, but it looked, well, like paint. One of the wonders of the Healing Brush is its ability to maintain the underlying texture of what is being cloned. I could use the Healing Brush now that the bright spot was closer in tonal value to its surrounding areas. The Healing Brush blended the adjustments nicely, and I finally had a beautiful glamour shot with a hint of highlight remaining where I wanted it.

One of the wonders of the Healing Brush is its ability to maintain the underlying texture.

ADVANCED TOPICS

BEAUTY LIGHTING

What follows is a step-by-step demonstration of how our sample beauty image was created (page 94, left). We'll show each addition to the set and its effect on the image.

We start off with a thunder-gray seamless backdrop and a simple table. The gray backdrop will go black because the light from the main light will fall off considerably by the time it reaches the backdrop. A strobe head fitted inside the 30x40-inch softbox was chosen as the main light for these images because it is a relatively large light source that still retains a bit of contrast that will make your images "pop." However, I don't want a rectangular shape as my main catchlight. A Circlemask (discussed on page 45) will create round catchlights. The softbox with the Circlemask is then moved into position directly in front of and close to your subject, raised high and angled down. A reflector is positioned to catch the light that misses the subject and bounce it back under her nose and chin. I placed the softbox in a horizontal position for this series. I do not normally use a softbox in the horizontal position for beauty and fashion work because it tends to spread the light too much and can give an illusion of a heavier subject. However, we now have a circular light source, so the orientation of the box does not matter. Placing the softbox in the horizontal position gives me more room to tuck my camera in close.

The base exposure was set at f11 and was metered by placing an incident light meter at the model's cheek and pointing its dome directly down the lens (*not* at the light source). Remember that viewing your LCD is *not* an accurate way to judge your exposure! A high-quality light meter is needed to create consistent, professional images—especially with digital capture. Previews *do* come in handy to check your basic setup and to troubleshoot potential problems. I will show you some very common problems that can occur with this setup later and will discuss how I used the LCD screen to monitor the way the shot came together.

There is still some dimension to her face, but the shadows are much softer and the emphasis really does become her face and the makeup. However, the image still lacks a three-dimensional feel—and you won't make many hair clients happy

I do not normally use a softbox in the horizontal position for beauty and fashion work. . . .

Left—Your client for a beauty headshot is usually a cosmetics or hair product manufacturer, so your lighting has to show off the wonders of these products! Your lighting will therefore be very different than it would for a classic or formal portrait. Portrait photographers usually look for a smooth transition from your highlight side to your shadow side of the image. In many cases, the highlight side will be 1 stop brighter than your shadow side, resulting in what is known as a 3:1 lighting ratio. In contrast, you want your lighting for a beauty headshot to be virtually shadowless—let the cosmetics accentuate the contours of the model's face. At the same time, you want her hair to sparkle—just look at what that new shampoo/conditioner can do! **Center image and diagram**—With the main light in place, we see that the light from the softbox is beautiful and soft—just what we wanted—and creates that pretty butterfly shadow under Heatherlyn's nose. However, our clients don't want shadows! The addition of a silver card placed at the level of her chest and angled toward her face will take care of it! **Right image and diagram**—A beauty headshot is created by producing a virtually shadowless image. We are using one main light, so we will need to add a reflector to fill in the shadows under her nose and chin. But it is not enough to simply toss down a silver card on top of the table. We need to angle the board so it catches the light and puts it where we want.

with this image! The next step is to add hair lights—but what kind, and how do you expose for them? The use of different sized lights for hair lights was discussed in chapter 3. Larger light sources are softer and spread the light more evenly than do smaller lights like spotlights. Larger light sources also have less contrast than smaller lights, so they can also be "turned up" more without risking overlighting or blowing out the highlights in the hair. I want a relatively large light source for an image marketing hair products. Medium StripDomes are the perfect choice.

The image is starting to come together. The medium StripDome was brought in as close to Heatherlyn as I could get it because I wanted to maximize its size and softness (also remember that a light source produces a "softer" quality of light as it is moved closer to your subject). I also wanted her hair to "pop" off

the page, so I set the exposure of the hair light at f16—a full stop brighter than the main light. A full stop difference is really pushing the limits of what you can record with digital capture, but as you can see, it works beautifully with a large enough light source. (*Note:* I would have set the hair light to be ⅓ to ½ a stop less than what was done here if I was using the small StripDome, and I probably would have balanced it equally with the main if I was using a spotlight.) The hair light was metered by placing the incident meter at her hair and pointing it at the light. This image could easily work as a final photograph, but we still have room to *play*—besides, this is a hair advertisement! I added a second medium StripDome to the opposite side of the set to complete the image . . . and the setup was fast and easy!

Well, okay, it was a little more complicated. The hair lights were positioned behind Heatherlyn and angled back toward the camera—a real recipe for disaster, especially because they were set to produce 1 stop more light than what the

Left—As noted earlier, StripDomes are perfect tools for producing soft, beautiful hair light. **Center**—Now we have accomplished all that we set out to do: Heatherlyn's face is lit cleanly and beautifully, and her hair definitely has a shine to it. **Below**—Problems with flare when shooting against a white backdrop were detailed in chapter 3. However, it's not a problem that occurs only with white backdrops. The diagrams included in this section show the use of black flags. The black flags are used in this setup for two purposes. First, they do help add a touch of contour to Heatherlyn's cheeks by subtracting (absorbing) some of the light from the softbox and reflector. Second, and most important for this discussion, they provide a shield that blocks the light coming from behind your subject from entering your lens. However, the flags need to be positioned properly or they won't work. The LCD screen was highly effective in showing the results of moving the lights and the flags.

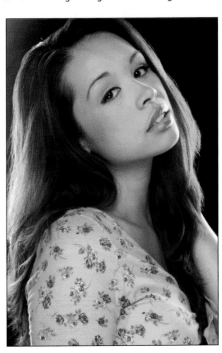

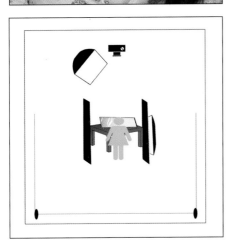

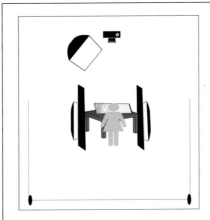

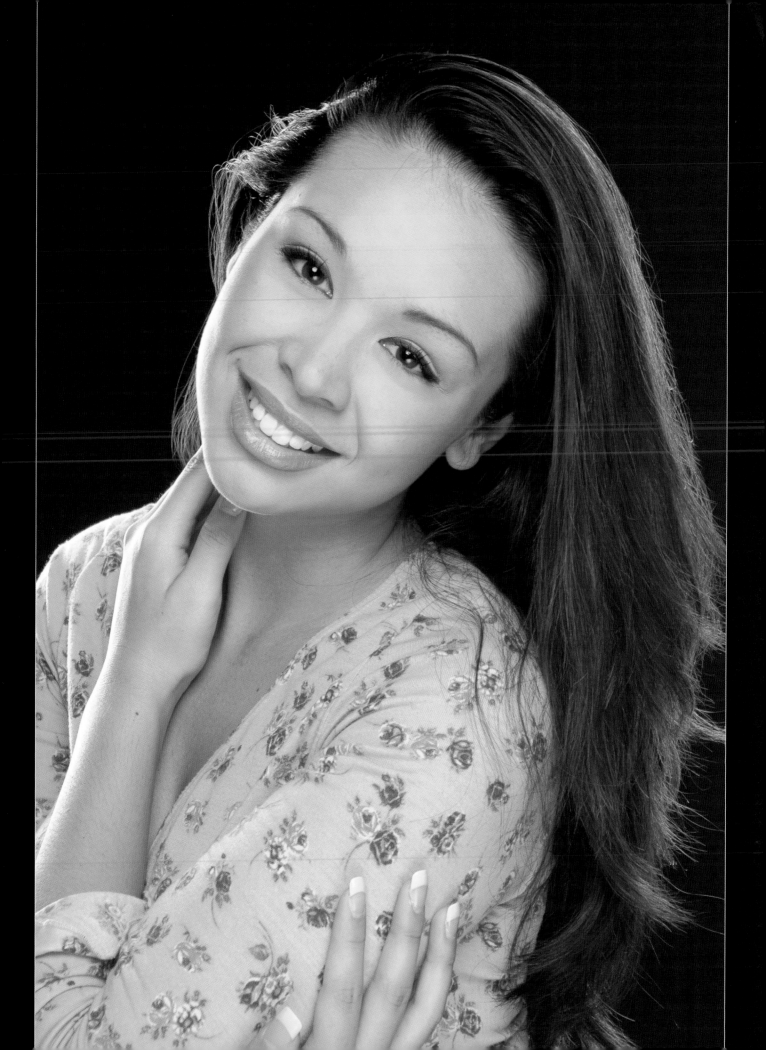

camera was set for! Once again, flare occurs when more light enters your lens from behind your subject than what the camera is set for.

Interplay with Spotlights. While the technique just described is clearly my favorite, beauty headshots can be created in a variety of ways: all it takes is a little imagination. Two sets of beauty images of Midori Every were shown earlier in this book (pages 32 and 40). One set used the technique just described, and the other set used a Halo as the main light. Other techniques can be used to create very effective beauty and hair shots too. The image of Debbie Brown (below) was created to show a variation of one of my favorite fashion lighting techniques. The fashion technique uses three spotlights above and on either side of the camera to create a harsh and edgy lighting scheme.

Facing page—It took some maneuvering to get the lights and the black flags into the proper position. I kept shooting and checking the LCD screen as Ed kept tweaking the position of the lights and the flags until I got the hair lit beautifully and with no flare! Angling the black flags and inching them slowly toward the StripDomes as well as changing the angle of the StripDomes worked. **Above**—Three spotlights were used as main lights to create this edgy fashion look for Teresa Bringas. Two spotlights were placed on either side of the camera and were fit with 40-degree grids. A third spotlight was fitted with a 3-degree grid and was placed above and behind the camera. Each light was exposed at f8 for a combined main exposure of f11^5/$_{10}$. Two spotlights lit the white backdrop at f16^5/$_{10}$. **Right**—Here three spotlights act as a slight fill for the 40x60-inch softbox. The softbox creates a soft light to begin the beauty lighting, and the spotlights add a "pop" and fill in all the shadows.

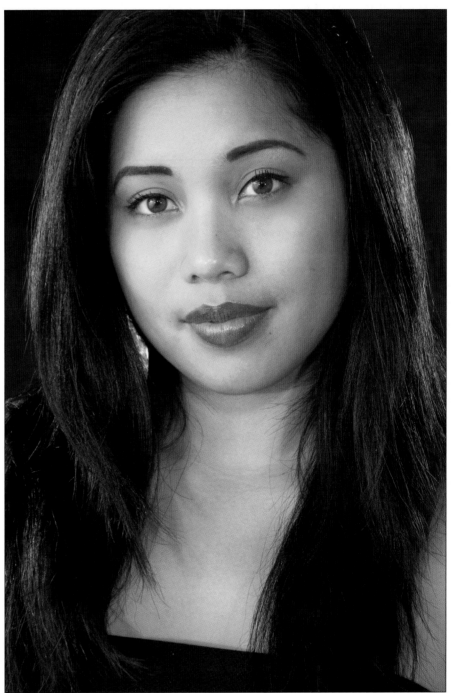

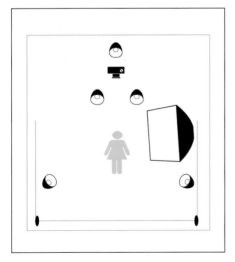

The same three lights were used to create this beauty headshot of Debbie Brown. However, the two side strobes were fit with 20-degree grids, and the combined exposure of the three spotlights was f5.6%/10. A 40x60-inch softbox was positioned to camera left and was exposed at f8. The overall exposure was f8%/10. Two spotlights were used to light Debbie's thick black hair. These spotlights were fit with 40-degree grids and exposed at f11. The camera was set at f9.

PLAYING WITH COLOR TEMPERATURE

The issues related to color temperature were discussed in chapter 2 and demonstrated with executive portraits on pages 56–57. Playing with color temperature can add some extra zest to your beauty or fashion images. To do this, you can selectively manipulate the color temperature of your lights on the set, or manipulate it in postproduction when shooting in digital RAW mode.

I started with my usual beauty lighting setup (detailed above) to create this lovely headshot of Christine. I was looking for something different for her portfolio, so I switched the white balance to incandescent light (about 3200 degrees Kelvin) and taped a Full Color Temperature Orange (CTO) gel inside the softbox that was illuminating her face (don't forget to re-meter because the gel will "eat" some light). I left both hair lights and the background light ungelled. The Full CTO gel theoretically brings the color temperature of the main light down to approximate the Neutral Rendering Point of an incandescent white balance. However, in actuality, a Full CTO gel actually brings the color temperature of a daylight source lower than the tungsten 3200 degrees Kelvin. Therefore, I added a $\frac{1}{8}$ Color Temperature Blue (CTB) gel to the Full CTO! All the other lights, white balanced for 5500 degrees Kelvin, are at a much higher color temperature than the tungsten white balance and record as blue. It's a simple trick that created a completely different look for Christine's portfolio. A similar effect could have been achieved by shooting a daylight setting and leaving the main light ungelled and placing Full CTBs on all the other lights. You can play with creating this effect in Photoshop, but I think it still looks better when created in the camera.

The color temperature of your light sources can have a dramatic effect on your image. With digital photography, we are often using a custom white balance to ensure that the image is rendered neutrally. However, color temperature can also be selectively modified to create a desired effect.

The image of Monica Ivey was created by placing two medium StripDomes on either side of her. A spotlight with a 20-degree grid was used as a fill placed along the same axis as the camera. There was a $1/4$ Color Temperature Orange gel placed over the fill light to give the image a slightly warm look (the white balance on the digital camera was set at 5500 degrees Kelvin).

OTHER APPLICATIONS: PRODUCTS AND INTERIORS

We'll return to the topic of photographing people shortly. There are many more situations where softboxes are effective tools in photography. We'll explore just a few times where I have used the tools and principles described in this book to areas of photography that have not involved people. Products and building interiors often need to be lit with artificial light (strobes or hot lights) in order to produce a commercially useful image. The same considerations that have been

PHOTOSHOP TIP: "SOFTENING" YOUR SUBJECT'S SKIN

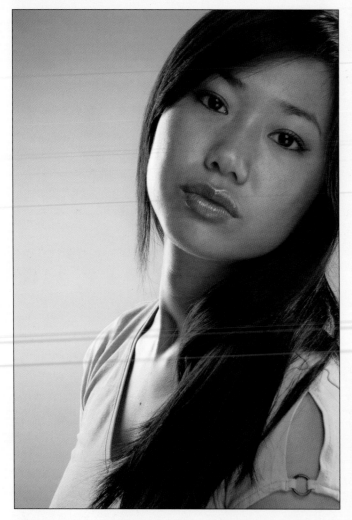 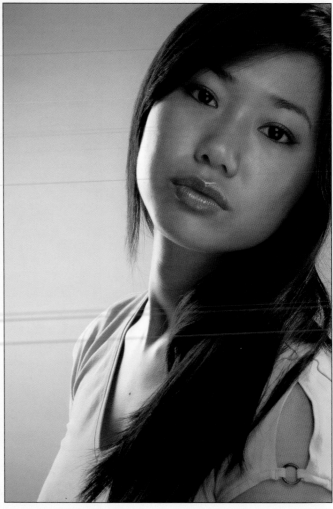

Working with layers—and saving a version of the image file with all the layers intact—is a must in Photoshop. I decided that the blur was still a little too much for this image, so I simply lowered the opacity of the blurred layer more during the last round of edits.

Christine has beautiful skin, but there may be times when you need to smooth out the skin for your subject. Here is one simple technique that employs the Surface Blur filter and layer masks:

1. Open your image and make a duplicate layer (Ctrl/Cmd + J).
2. Do all of your retouching on the duplicate layer.
3. Make a duplicate layer of the retouched layer.
4. Go to the Filters drop-down menu and choose Blur>Surface Blur.
5. Play with the Radius and Threshold sliders until you get the effect you want. Click OK.
6. Go to the Layer drop-down menu and choose Layer Mask> Reveal All.
7. Make sure that the layer mask is active and select the Brush tool with black as the foreground color (painting with black on the layer mask will reveal the underlying layer). Paint your

subject's eyes, eyebrows, lips, and hair at 100% opacity (there is an opacity slider for the Brush tool in the Options bar). You can change the opacity as you like to paint back in other parts of the image.

The image of Christine was selected for demonstration purposes, so the effect was applied to a minimal degree. Other images may need more of a blur. Be careful because this is a powerful filter and your image can easily become unrealistic. If you do need to go fairly heavy with this filter, then you can still adjust the opacity of this layer in the Layers palette. Lowering the opacity of the layer will let the underlying layer show through to the degree selected. Use the Opacity slider to blend the blurred layer with the texture from the underlying layer for a realistic look.

8. Create your color correction Curves adjustment layer above the blurred layer.

discussed with respect to photographing people come into play in product and interior photography as well. You use the tools that you have available to you to present the product in its best form. The type of product photographed and the size of your light source will be key factors in how your image looks. Certain materials—like glass, for example—may be best photographed with large light sources while others can handle the increased specularity of small lights. You will often use a combination of both, depending on what you are photographing. The first image shows an approach to photographing glass. Glass is obviously a highly reflective surface. Small lights will create sharp and dense highlights that could easily create a white blob in glass. Larger light sources will create broad and soft highlights that can accentuate the surface of the glass. You also need to be aware of the angle at which your light is hitting the glass, just like when photographing a person wearing glasses. My choice for lighting glass is a large light source positioned at an almost 90-degree angle to the camera. I'll use reflectors or flags as needed to add highlights or shadows.

"Tents" are also very good for photographing glass because the light becomes very soft and diffuse. Lighting tents are available from many manufacturers of

The best lighting scheme for these small perfume bottles was a simple one. The image was created many years ago, so I don't recall if I used a large softbox or if I fired a strobe through a scrim for the main light. The large light, positioned camera left of the bottles, catches the subtle nuances in the design of each bottle and produces large even highlights that define the shape of the bottles rather than creating blown-out hot spots. The image was created on 4x5-inch transparency film, so the exposure demands were similar to digital capture. The light is positioned to feather across the bag. Feathering your light across fabric will bring out the texture more than a head-on lighting scheme.

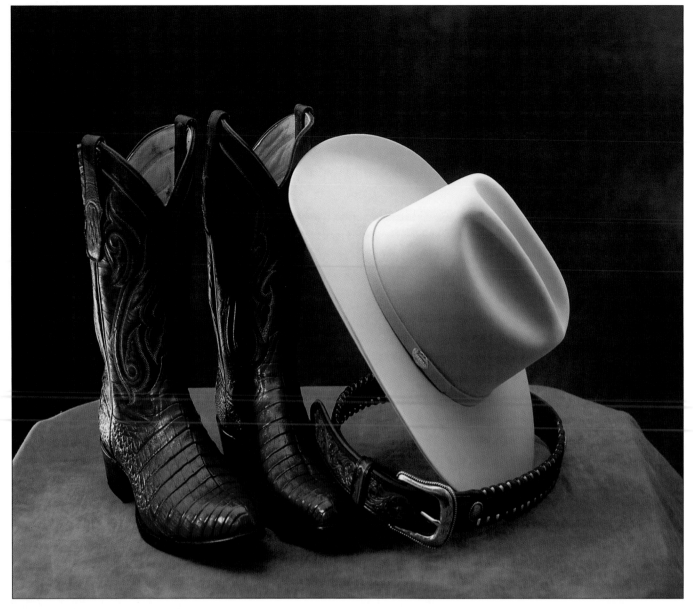

One of the wonders of a true view camera is the ability to shoot at a high angle and use the camera's swing and tilt controls to maintain the proper perspective of the product you are photographing. I wanted a higher camera angle to show the leather from inside and outside of the boot, but shooting down on the boots with an SLR camera would have added some distortion and made the angle and shape of the boots look odd. Tilting the back of the view camera allows you to choose the angle from which you want to photograph your subject while keeping the film plane parallel to the subject plane so the product looks right in the image.

light modifiers. I created my own "tent" for this Western apparel advertisement. The "tent" was created by touching the top of a large softbox on one side of the set to the top of a scrim on the other side. A ¾ Color Temperature Orange (CTO) gel was taped to the strobe firing through the scrim to add a little amber hue to the hat. The ¾ CTO dropped the color temperature of that light and added warmth to the image. The light in the softbox (camera left) was feathered across the boots and provided a nice highlight on the belt buckle. The image needed a little "kick" (no pun intended!), so I added a spotlight behind and to the right of the boots. The harsher light draws attention to the detail in the boots.

There is a lengthy discussion later (chapter 6) about using artificial light to "match" the mood of your surroundings when shooting outdoors. The same approach is often used in shooting building interiors. When lighting a room, we usually strive to re-create the light that naturally occurs. Your tools, as always, will dictate how this is accomplished. Spotlights are often very effective in lighting a large room, but softboxes can play an important role too. Often, the goal is to simply take the existing light in the room and raise the ambient light to a level that can be photographed effectively. Your tools can then be used to highlight certain parts of the room. The following examples show the use of spotlights alone to light a room and then the use of a Halo to match the feel of a kitchen showroom.

There were a number of other things to consider when photographing the following kitchen scene. The kitchen was actually part of a showroom, so the working space was extremely limited. The kitchen faced a large window that allowed a good deal of soft, diffuse window light to fall onto the set. The task here was again to raise the ambient light and also highlight parts of the kitchen. We needed a soft main light to match the feel of the room (and to avoid losing detail in the white walls). The trusted Halo was used and was positioned next to the window and angled in toward the set. Three spotlights were used to add accents to parts of the room. The copper pots and pans were lit by a spotlight po-

Palominos Restaurant in downtown Honolulu is a beautiful place to have a meal. The room is lit by many small pinlights all along the ceiling as well as pretty light fixtures along the pillars. The challenge was to light the room in a way that would maintain the look and feel of the ambient surroundings. My friend Stan Cox II and I decided to hide five spotlights around the room to even out the light from the camera position to the back wall. As noted, it was important to maintain the feel of the restaurant, so the shutter of the camera was slowed down to 1/8 of a second to record the light in the room as well as the light from the strobes. The aperture was a modest f8, but the size of the room helped to maintain enough depth of field to keep most of the room in focus.

sitioned along the window as well. Another spotlight from almost the same position added some detail to the plant on the bottom shelf of the table. A third spotlight was hidden behind the faux kitchen and kept the back of the set from going too dark.

A Halo was used to create a soft main light effect that provides the illusion of a kitchen lit by a large bay window. Specular highlights were added with spotlights in key places.

LIGHTING ON LOCATION

. . . this often means that you will pack most of your studio to go with you on location.

*W*e have been discussing the different results that you can obtain with different light modifiers throughout this book. Your choices are the same on location as they are in the studio. However, you are in complete control in the studio: you can choose to use spotlights for a harsh effect or a huge softbox for an ultrasoft feel, and everything in between. You still have those options on location, but you are now dealing with an ever present—even if ever changing—light source known as the sun, or the ambient (existing) light created by the sun. There are many times when you will need to augment or even change the light present in a scene. It is not wise to think that location lighting is a one-size-fits-all situation—especially when strobes are used outdoors. Each scene has a natural "feel" to it. Your images will generally be more successful if you choose your additional lights in such a way that it does not become "obvious" that the scene was lit. Get a sense of how the existing light "feels," and choose a light modifier that will blend into the scene.

Of course, this often means that you will pack most of your studio to go with you on location. Most of this series of images and illustrations were made for a session that spanned two days. The latter part of the set was photographed in a local park and on a "light" day. The basic travel kit consists of a heavy-duty tripod, a studio strobe, a light stand and counterweight, gridspots, two external battery packs for the strobe, a Halo-style softbox, reflectors (including a Plexiglas mirror), and scrims. Our second outing consisted of a road trip around Oahu where we ventured into the trails in the heart of the island as well as her beaches. We did not know what to expect, so this trip also included an umbrella and a 30x40-inch softbox in addition to cameras, light meters (you need a meter that reads the ambient light plus the light from your strobe), and a color card. Many thanks to Marshall (who also brought a "regular" umbrella, which came in handy in the jungle!) and Glenn who shared the duties of hauling the gear

around Oahu while John helped make me look good in the park (a good assistant is an incredible asset on any shoot, but especially on location). The series features Ashley, who is as friendly (and, as you will see, silly!) as she is beautiful. She brought the most important location gear—the mosquito repellent.

Our "road trip" is shown first. This portion of the photo shoot took place between noon and 3:00PM, so the sun illuminated the tops of the trees and ground unblocked by the forest canvas with bright, harsh highlights. Despite the highlights, the light illuminating your subject in the dark shade will be a great deal less than what the direct sun will read, so you will need to bring in a strobe for a main light. The black-backed silver umbrella and a mirror were chosen to light Ashley under the trees because I wanted a broad but harsher light source to mimic what could be directional sunlight. Ideally, we'd like to use the strobe to balance the light under the trees with the highlights behind our model. In reality the strobe will become the main light with the sun providing highlights behind her. We got an idea of our base exposure by metering the unfiltered sun with the dome pointed toward the sun. This method is usually a highly accurate way of metering non–front lights and is critical when keeping sunlit highlights on your subject's skin from losing detail with digital capture. However, the deep greens of the forest "eat" much more light than you might think. The LCD screen on your digital camera can give you a general sense of how your highlights are being recorded, but don't rely solely on your LCD screen. Like I said, we get a basic starting exposure point by metering for the highlights. We now know what to set our strobes for: we want our main exposure to be in line with, or slightly less than, the highlight exposure. In all cases, the main exposure consisted of the strobe light combined with the ambient light under the trees and was determined by using a handheld incident meter set to read the light from the strobe and the ambient light together.

Creating the images that I had envisioned was not that easy. Partly cloudy skies are the norm in the mountains of Oahu, Hawaii, so the light illuminating the backdrop is constantly changing as the sun sneaks in and out of the cloud cover (the clouds over Central Oahu wreak havoc on your lighting plans). Murphy's Law will dictate that you'll get the best expression from your model just after the sun tucks itself behind the clouds. Your main exposure won't be affected too much because the ambient light under the trees won't be adding much light to your exposure, so it will be your backdrop that is primarily affected by the "sudden" cloud cover. Some basic to intermediate Photoshop techniques can help you in these situations, but remember that you are starting with an image where the most important part of the photograph, your subject, is properly exposed. You are not using Photoshop to "fix" a bad image: you are using the tool to enhance your image to create what you envisioned. The Photoshop techniques used to create these images will be detailed as each image is described.

Every digital image requires some degree of color correction. Color correction is important because it neutralizes any color casts in the highlights, shadows, and midtones. You can guess at what looks good on your monitor, or you can color correct by the numbers. The technique described here is a compilation

I wanted a broad but harsher light source to mimic what could be directional sunlight.

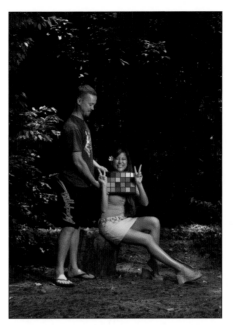 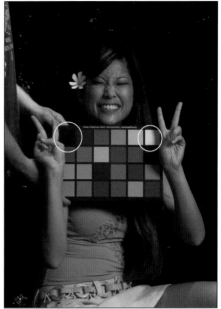

of several techniques described by Photoshop gurus (including Eddie Tapp and Dave Cross). We'll start off at a pretty basic level, but it will get a little more complex. You will need to familiarize yourself with three palettes and/or dialog boxes in addition to your toolbox. Drag the Info palette from wherever you have it docked in your workspace. Do the same for your Layers palette. Hidden at the bottom of the Layers palette is an icon to create an adjustment layer. When you click on the icon, select the Curves menu, and a Curves dialog box will open. You will see three eyedroppers—one for the white point, the gray point, and the black point—in the bottom-right corner of the Curves dialog box. The eyedroppers are used to force the chosen spot of your image into a preset value.

The first step is to set these values. The key is to determine what part of your image falls within the black and white ranges and set those spots to a predetermined value that corresponds to black without detail and white without detail. The range of values is currently on a numeric scale from 0 to 255. Zero is black without detail, and 255 represents white without detail. However, many people who work with digital images recommend setting the black value to 10 and the white value to 245 to compensate for printing issues. I use 10 and 245, but you'll have to experiment with the values.

1. Double click the black eyedropper and set the values you want. I work in RGB mode, so I set each RGB value to 10.
2. Click OK.
3. Double click the white eyedropper. I set each of the RGB values to 245.
4. Click OK.
5. The gray eyedropper is used to correct any color cast that is not "fixed" by the first two adjustments.
6. The value for each of the RGB settings is usually in the middle of the range, perhaps 128 each. Double click the gray eyedropper. I set each of the RGB values to 128.
7. Click OK.

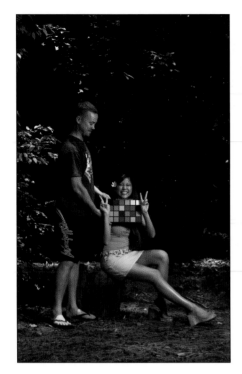

Left—Setting the white point by using the white eyedropper brought the white values in each of the three color channels in line and brightened the image at the same time. **Center**—Setting the black point in this image to the preset values darkened the shadows too much and created too much contrast. **Right**—Using Dave Cross's technique of using a 50% gray fill layer and the Difference blending mode will help you find a value closest to midtone gray for color correction purposes.

Now that your presets are selected, these values will help you to color correct many images, but we will take this idea a little bit further.

The technique described will allow us to combine the use of preset eyedroppers within the Curves dialog box, adjusting the "natural" colors for part of the image, and using a technique described by Dave Cross for finding the midtone gray in your image. Color correcting this image was made easier by including a GretagMacbeth color card (the "color card" shots are always fun with Ashley!), but you can use the same techniques with any image. The color card is placed where all of your lights combine to illuminate the most important part of your image.

Finding the white and black points is fairly easy in most photos, even without a color card. Finding the midtone gray is trickier, even with a color card. We'll use the Color Sampler tool (hidden within the Eyedropper tool in your toolbox) and the Info palette to determine the white and black points and set where we want to change the values. Select the Color Sampler tool and move your cursor around the image. You will see the RGB values change in the Info palette as you move through the image. Clicking on any point in the image will "set" a point to be corrected. We are looking for white and black points, which are conveniently located on the color card. We'll select a spot for white and black within the respective circles indicated below.

The white point selected has values of 221 for Red, 209 for Green, and 200 for Blue. The black values were 32, 28, and 27 respectively. Bringing these values in line will neutralize a great deal of color problems in this image. Here is how to start the process:

Using the gray eyedropper tool to neutralize the midtone gray selected in the previous step also brought the blacks in line. This seems to happen fairly frequently with this technique.

Click the Adjustment Layer icon in the Layers palette and choose the Curves adjustment. Never make your adjustments on your original layer. Make adjustments and edits on duplicate or adjustment layers and your original data is left untouched—you can keep editing or even throw away dupes or adjustment layers and start over if need be. Select the white eyedropper and click on the "target" established by the Color Sampler tool.

Now we'll set the black point. Select the black eyedropper and click on the black target.

The results of this adjustment were not what we were looking for, so we dumped the adjustment layer and started over. The areas selected for the white and black points were fine, so we reselected them. This time, however, we will use the midtone gray to help us. But, which of the three gray squares on the color card is really midtone gray for this image? How would you find midtone gray without a color card? Dave Cross provides the following technique:

1. Make a duplicate layer (Ctrl/Cmd + J).
2. Add a fill layer (Shift/F5)—select 50% gray.

Yes, you have just created a solid gray image. Have no fear, we'll take care of it.

Go to the Layers palette and click on the Blending Mode drop-down menu (upper-left corner). Choose Difference. We are "blending" a solid 50% gray layer with the underlying image. The values in the underlying layer that are closest to 50% gray will appear darkest, so find the points that are closest to black and use the Color Sampler tool to select those values. In this case, it looks like the third gray square from the left is closest to midtone gray. We used the Color Sampler tool and selected a spot within the circle shown below.

Drag the gray layer to the trash can at the bottom of the Layers palette. Your selected spot(s) will stay on the underlying layer!

We will create a Curves adjustment layer as described above, first setting the white point as above. Next, though, we will select the middle eyedropper and click within the target chosen for midtone gray.

This image did not need any more work in the blacks because the gray eyedropper tool also neutralized the blacks. However, there are times when the blacks need a subtle tweak. We saw what happened when we used the black eyedropper tool before, so any final adjustments will be done by looking at the Info palette and manually bringing these values in line by selecting the individual channels from the center drop-down menu in the Curves dialog box. Your blacks will be represented by the lower-left corner of the Curves grid if the grid is set for screen view (your blacks will be in the upper right if the grid is set for print values—there is a toggle button in the middle of the horizontal axis). Simply click and drag the bottom-left corner of the grid and drag to the right while watching the Info palette. Stop when the numbers line up. Do this again with the channels that are still out of alliance.

Don't close the Curves dialog box just yet! Click Save, and you'll be able to save this adjustment for use in other images shot under the same lighting conditions—just be sure to give it a distinctive name.

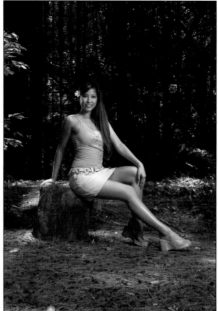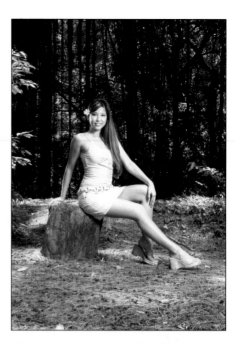

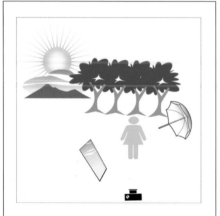

Left—The initial image isn't bad, but as with all digital images, it could use a little help. **Center**—You can easily color correct any image from a series by "loading" an adjustment saved from an earlier correction process. **Right**—The Screen blending mode will dramatically lighten your image—often much more than you want!

Click OK if you want to apply the adjustment layer to the image that you used to create the adjustment. As noted above, Ashley's color card shots are always worth keeping! (Thanks for your help, Marshall!)

Now that we have our color correction set for this series, let's get back to creating the image that we wanted. I knew that we'd have harsh spots of sunlight dappling through the trees, so I wanted to create a fairly harsh light to go along with the scene. I chose a medium to small umbrella for the job. The umbrella was set up at camera right. Marshall stood behind Ashley at camera left with a mirror to catch rays of sunlight to bounce back on her, creating an edge and separation light. The area circled in the image below would become a problem because the direct ray of sunlight hitting Ashley's hand was a lot brighter than the exposure of f13 ($11\frac{1}{3}$) at $\frac{1}{50}$ of a second.

Color correcting this image was simple because we saved the Curves adjustment created a minute ago. Simply click on the Adjustment Layer icon at the bottom of the Layers palette and select Curves. Choose Load from your choices in the dialog box, then simply select the saved adjustment. Click OK and you are done!

The image looks pretty good with this simple adjustment in place. The backdrop looks better than it did in the color card shot (the sun came out!), but we'll make it look even better in a minute. The Curves adjustment created two problems here: Ashley's skirt, which is partially lit with sunlight, is now too bright, and we have lost detail in her hand. We'll tackle the backdrop first.

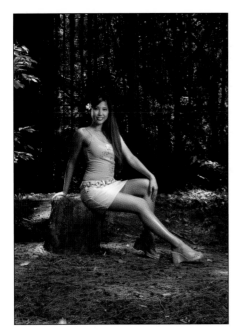 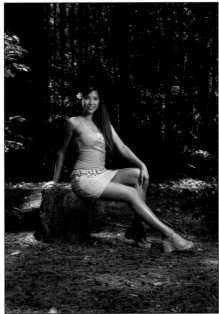 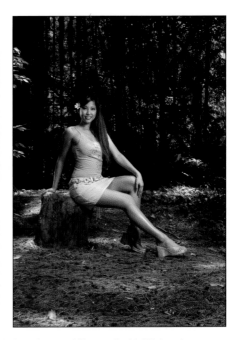

Left—We added a layer mask and used the Brush tool at different opacities to lighten the backdrop in key places, adding to the highlights that nature provided. Be careful and don't overdo it—you want to enhance what is there, not necessarily create a new backdrop (we'll show you how to do that later). **Center**—The use of duplicate layers, blending modes, and layer masks do wonders for "fixing" minor problems in parts of your image. **Right**—In reality all of the adjustments detailed for this image took about five minutes to complete.

Make the backdrop layer active by clicking on it. Make a duplicate layer. Change the blending mode to Screen (this option will lighten all pixels darker than midtone gray). We have just ruined our image!

Now go to the Layer drop-down menu and select Layer Mask>Hide All. You are back where you started from. Click on the layer mask box in the layer (Layers palette) and choose the Brush tool. Set your foreground color (lower part of your toolbox) to white. Notice the Opacity slider on the Brush Options bar. Choose a soft-edge brush and paint in the screened layer where you want it and at the opacity that you want (change the opacity at various parts to ensure that the result appears realistic).

So, now we have the look we want from Ashley, the overall lighting that we want, and the backdrop that we envisioned. However, we still have a problem with Ashley's hand and skirt.

We fixed her skirt by duplicating the original layer and dragging it above the layer with the screened forest. We changed the blending mode to Multiply (for the opposite effect of the Screen blending mode) and again created a Hide All layer mask. We carefully painted in the skirt at a low opacity (somewhere around 20 to 25%).

Fixing the blown-out portion of Ashley's hand was a little more complicated. The image was captured in RAW, so I went back to the original image and opened it again. This time I used the preview panel in the RAW conversion dialog box (Photoshop CS2) and adjusted the Exposure slider until the highlight warning disappeared (about 1 stop underexposed), then clicked Open. I then used the Move tool to drag the dark version on top of my working image (hold the Shift key when dragging the image to center the new image on the old one). I moved the dark layer down the Layers palette (click and drag) and positioned

it just above the original Background layer. I then chose the elliptical Marquee tool and made a loose circle around Ashley's hand, then hit Ctrl/Cmd + J to make a new layer of her hand. I could now discard the dark layer (drag it into the trash can). I then dragged the dark hand layer to the top of the Layers palette—above the Curves adjustment layer—created a layer mask, and painted her hand in to the desired amount. As a final adjustment, I double clicked on the Curves icon in the Curves layer and pulled the diagonal line up a little from the center—just to lighten the image a little more.

What if the sun does not cooperate when you get the expression you want? We moved Ashley over to a big tree near the stump from the last shot and repositioned the same umbrella for the main light. Ashley's shirt lost a little detail because we were trying to shoot slow to capture some of the detail behind her (f6.3 or f5.6⅓ at ⅟₈₀ of a second). I brought the detail back in her shirt by using the same double RAW conversion technique just described. I liked the expression on her face and the pose, but the backdrop was too dark because again the sun was behind the cloud cover.

Fortunately there were other images from the series with nice detail in the woods behind Ashley. We selected one image with a nice backdrop and dragged

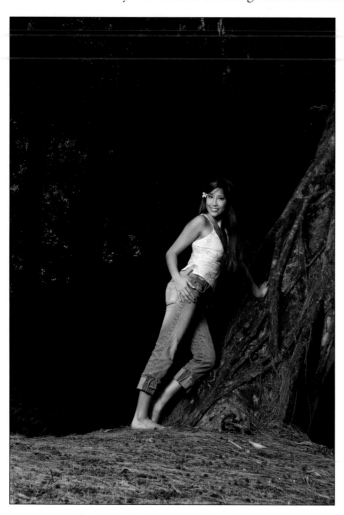 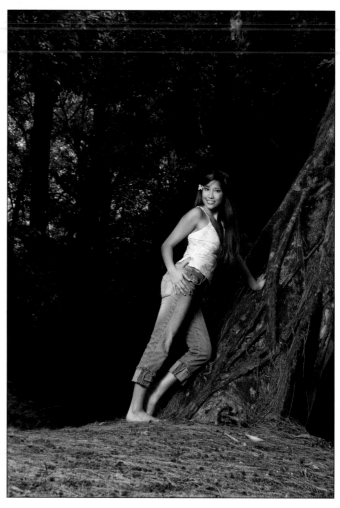

Left—There are times when everything in an image clicks—except for one component. In this case, nature was not cooperating and produced a backdrop without enough detail. **Right—**Creating composite images is one key to obtaining the look you envisioned when nature decides to be uncooperative! Mastering layer masks is an essential part of your Photoshop repertoire.

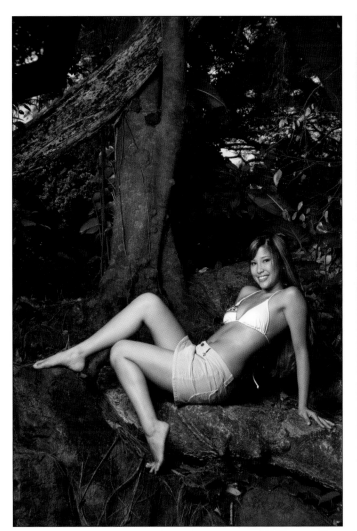

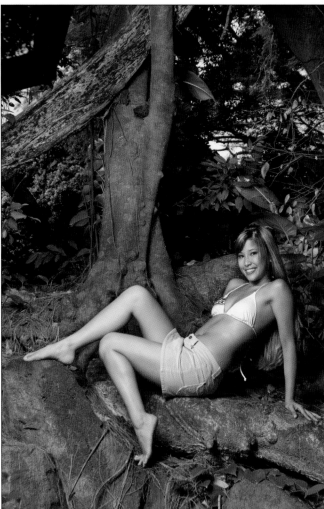

Left image and diagram—A carefully chosen light modifier and some basic Photoshop techniques combined to create a beautiful image of Ashley in the jungles of Central Oahu. **Right**—Using screened and multiplied duplicate layers with layer masks (above left) can be extremely helpful when you have to work with a JPEG image. However, this image shows, in my opinion, the vast difference that RAW capture provides. The same image was manipulated by opening the RAW image three times: the first time, it was opened as shot; the second time, it was opened with the exposure dial set to underexpose the image by a slight degree to hold detail in Ashley's bikini top; the third time it was overexposed by about a stop. The image was created using layer masks; I painted in detail where I wanted it.

it on top of the image I liked, created a layer mask to hide the new information, and used the Brush tool to paint in the "new" backdrop.

We still had a carload of equipment to play with. There was a section of this trail that was lit with soft yet directional light. There were still some strands of sunlight streaming through the trees, creating points of contrast—but the light was generally diffused. The umbrella may have created a light that was too harsh for this scene. The 30x40-inch softbox was perfect. The first of these two images was exposed at f7.1 (f5.6⁶/₁₀) at ¹/₂₅₀ of a second. It was important to shoot at the fast shutter speed because of the blue sky that is visible in the breaks between the trees behind Ashley. The blue skies also provide the illusion that the highlights in her hair are coming from sunlight when there is, in actuality, no direct sun lighting the scene. Once again, a layer mask was created from a screened dupli-

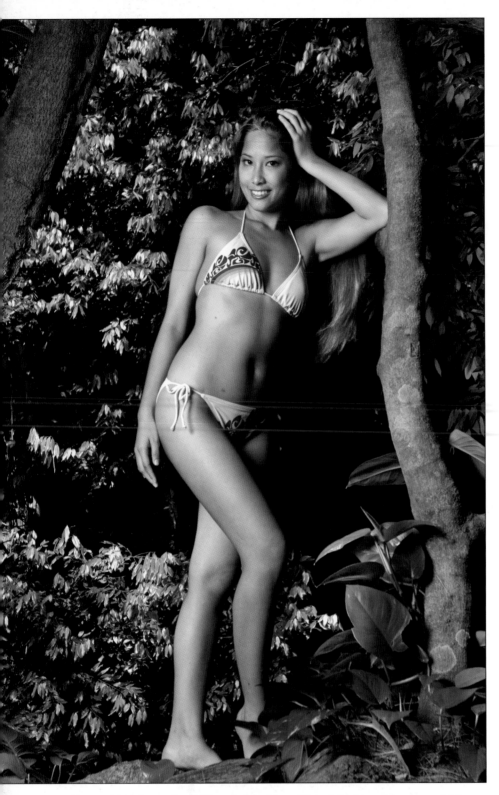

Left—A slight move created a whole new perspective for this scene. The sky is no longer visible, so we have the impression of being much deeper in the jungle. Once again, however, highlights on the leaves are visible behind Ashley. The same softbox provides large, even illumination that is set to apparently come from the same direction as the light creating the highlights. The backdrop was painted in using a second RAW conversion and layer masks. Don't let the smile on Ashley's face fool you: there was a 15-foot drop right behind her! I told you she was a good sport—except that for the fact that she kept trying to fire Marshall and Glenn. I told her to wait until all the gear was packed in the truck before firing the guys who were carrying the load. It was all in good fun. We had a blast!

Above diagram and facing page image—The light illuminating Ashley was the same as the light behind her, so there was no need for any layer masks to paint in detail behind her. A spotlight and reflector add a "pop" to her face and help "lift" her off the backdrop.

cate layer to brighten the foliage behind her. The right image on page 113 was created with multiple RAW conversions and layer masks.

Okay, so I've been telling a little fib in this section: yes, all these images were created as described and they were photographed in Central Oahu, but they were all taken about 50 to 100 feet from the road in the next image! The trail does apparently go a good distance into the forest, but we were hanging out at the start of the trail. We made one more stop before heading off to a new loca-

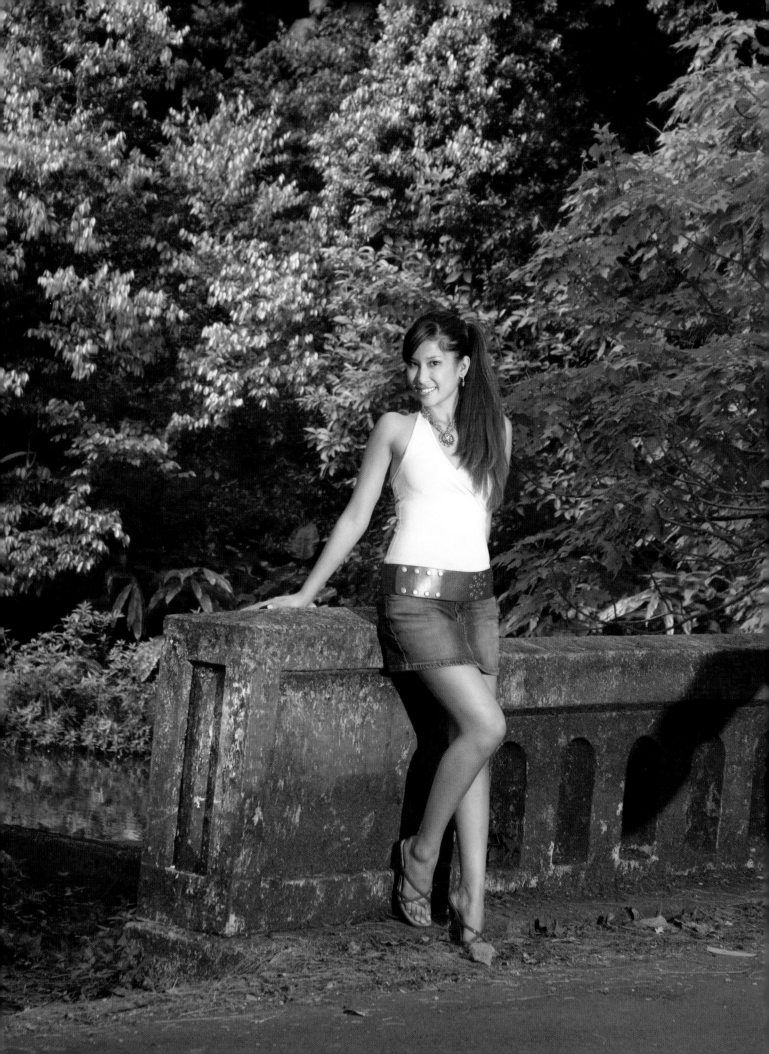

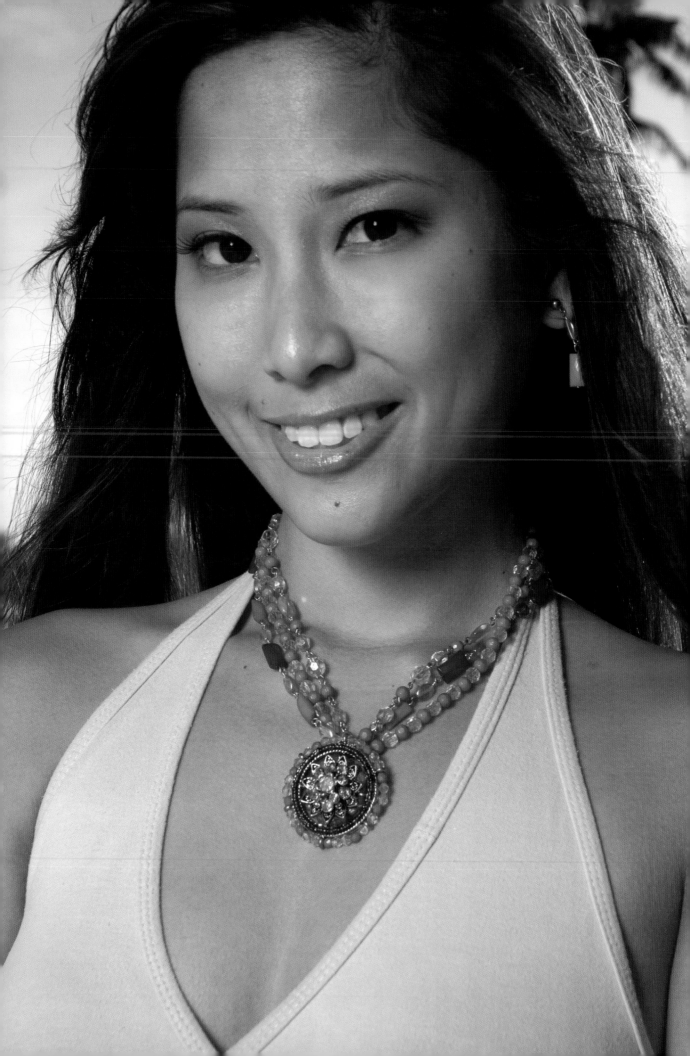

Facing page and above—The setting sun provides a beautiful amber hair light for this image of Ashley. The main light is a strobe stuck into a Halo-style softbox. I could have removed the tree behind her head, but it was out of focus enough that it doesn't bother me—and it helps to set the location.

tion. We placed Ashley directly across the street from our first location. She was now lit with sunshine—when it was not behind the clouds. The ambient light was harsh, so we chose a strobe with a 40-degree grid and a silver reflector to match the feel of the direct sunlight. No layer masks were used to create the backdrop, just a couple of Curves layers to color correct and bump up the overall look.

The trip was not over just yet. We ended the day at a beach on the Southeast Coast of Oahu. The sun was setting at camera right, so the light was soft and beautiful. However, we wanted to use the sun as a natural hair light, which meant that we had to choose a soft light for the main light. The Halo was the tool chosen. The sun read a little more than f11 at $\frac{1}{250}$ of a second, so the strobe/Halo/ambient combination was set for f10 (f8%/10) at $\frac{1}{250}$ of a second. The strobe was set opposite the sun, and no additional Photoshop manipulations were used to create this beautiful portrait.

Let's take a quick look at some of the technical aspects of modifying outdoor light. Sunlight by itself is a great light source for about two hours a day. "Magic light" refers to the brief time right after sunrise or before sunset. The sun is lowest in the sky and the light travels farther. The light rays are refracted more by atmospheric interference, resulting in a softer, more diffused light. Direct sunlight is way too harsh to be used as an unmodified solo light source for most people photography. (Quality of light concerns were introduced in chapter 1.) The sun is an unusable light source for most of the day because of its extreme distance from the Earth. The huge light source actually becomes a pinpoint light source creating harsh deep shadows. The key to creating pleasing people pictures outdoors is to either fill the shadows created by the sunlight and/or soften the light by expanding the size of the light. The size of the light source can be expanded by finding or creating open shade.

Scrims and/or open shade are very effective when the backdrop is also in shade. The light in the shade or under the scrim is much less harsh than sunlight, and it is also much less intense. You will have to either slow your shutter speed or open your aperture to obtain a proper exposure in the shade compared to direct sunlight. The area behind your subject is lit by similar light that illuminates your subject, so the only challenge is to make sure that there is a sense of direction to your main light.

However, using open shade or scrims can be disastrous when the area behind your shaded subject is lit by direct sunlight. The light behind your subject can be up to 3 stops brighter than the light in the shade or under the scrim. A 3-stop difference is difficult to hold with negative film, but detail will be completely lost with transparency film and/or digital capture.

One way to resolve this concern is to use a strobe to bring the quantity of light under the scrim or in the shade back up to match the light value of the background.

Halos were discussed in chapter 2 as a highly convenient and portable umbrella/softbox combination. They can be very effective tools to help balance the foreground (the light illuminating your subject) with the background while maintaining a soft quality of light.

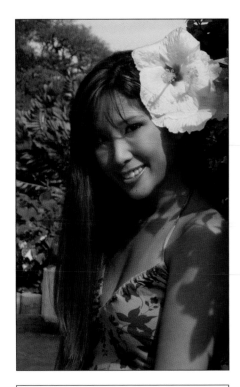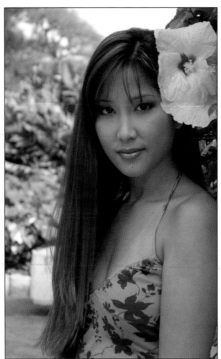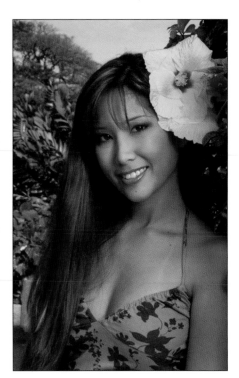

Left—The sun is a very harsh light source when it is high in the sky. Finding or creating open shade is one way to soften the light. You can use a scrim to create shade when natural shade is not available. A scrim is thin piece of translucent material stretched over a frame that is usually collapsible and easily transported to and from your location. **Center**—Here the light under the scrim is soft and diffused and still has a sense of direction to it. Unfortunately, the background is overexposed, the sky is washed out, and the bushes behind Ashley are lighter that I wanted. **Right**—The scene with Ashley was brought into balance by introducing a strobe tucked into a Halo to raise the light values under the scrim to match those behind her. This image was exposed at f13 (f11^{1}/$_{3}$) at 1/$_{250}$ of a second.

Adding a strobe to an outdoor scene can be complicated, especially when trying to balance the scene. In chapter 2, I introduced the law of physics known as the additive nature of light. We took a look at how this law works in the studio, but now we need to examine how it works outside. The strobe becomes a second light source because the ambient light, or the natural light surrounding your subject, is ever present. The effect of the ambient light, whether it acts as a main light, co-main light, or a fill light is up to you and how you want your image to look. Another factor to consider is the mechanics of capturing a strobe/ ambient image. You could essentially forget about your shutter speed when using strobes indoors, as long as you were shooting at or below your camera's sync speed and were not shooting at a very slow speed, you were just concerned with

setting your aperture correctly. Recording the ambient light as part of your scene now requires you to pay close attention to the shutter speed, the aperture, and the often delicate balance between the two. The task of bringing a brightly lit backdrop in line with a strobe-assisted foreground also often requires your camera to sync with your strobe at $\frac{1}{250}$ of a second or faster.

Quality of light issues are also important to consider when choosing the size of the strobe-powered light source. The strobe will have to overpower the light in the shaded area by a great deal and will therefore become the main light. The considerations and choices discussed in chapter 1 and at the start of this chapter about the size of your main lights are pertinent here as well. In this case, the scrim or source of shade will become a large, soft fill light, so the size of your strobe and/or strobe modifier will determine the quality of light that affects the image. As in the studio, there will be times when a direct, small and harsh strobe will create a very dramatic image, but you'll want to soften the light in most cases. As noted above, you usually want your lighting choice to blend in with the surroundings, but there are times when the opposite effect can be applied.

A camera that will sync with your strobe at faster speeds allows for more creative options when on location. I wanted to further darken the sky in this series of photographs of Ashley. I changed the shutter speed to $\frac{1}{500}$ of a second and re-metered the scene. The aperture was now f10 (f8%₁₀).

Left—The strobe becomes more apparent with the shutter speed set at $\frac{1}{500}$ of a second because it is now even more of a main light—the light patterns on Ashley are more defined by the strobe. The sky also has a rich, dark hue. **Right—** I was not happy with Ashley's hair and the trees behind her. They were too dark for my taste. Once again, I simply duplicated the layer, set the blending mode to Screen, created a layer mask, selected Hide All from the Layer drop-down menu, and painted in the highlights that I wanted—at the opacity that I wanted—with the Brush tool. I would use the RAW technique described above in the future.

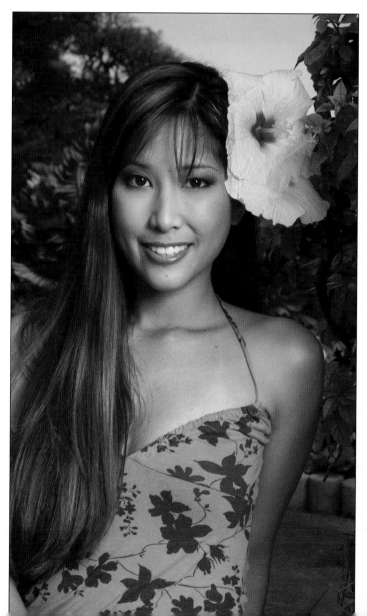
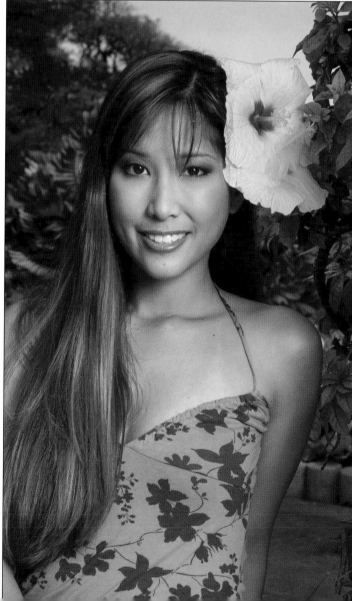

Don't be afraid to take your toys from the studio outside to play! By now it is clear that StripDomes are among my favorite toys in the studio. They also work really well outside. This time we took Midori Every into the jungles of Oahu. The medium StripDome was chosen to modify the strobe for this image.

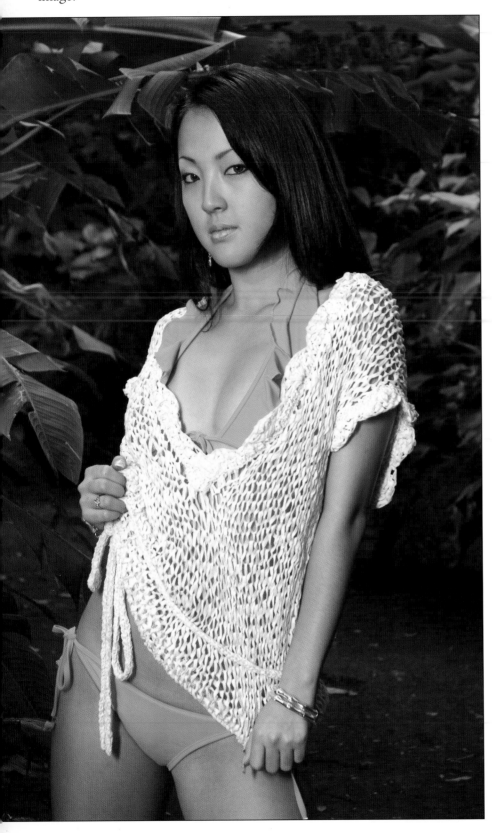

Swimsuit photography is extremely popular in Hawaii. The jungle scene puts a different spin on a popular theme. The ambient light measured about f4.5 at $1/60$ of a second. I wanted to maintain some of the ambient feel without risking motion blur by slowing the shutter much more, so the strobe/ambient combination for this shot was f6.3 (f5.6$1/3$). I still used a screened duplicate layer and layer mask to brighten the dark trees and Midori's hair.

The small StripDome makes an effective main light for fashion images outdoors too. In this case, the strobe/StripDome combination became the main light for this image of Tishanna Yabes—partly due to the fast shutter speed chosen.

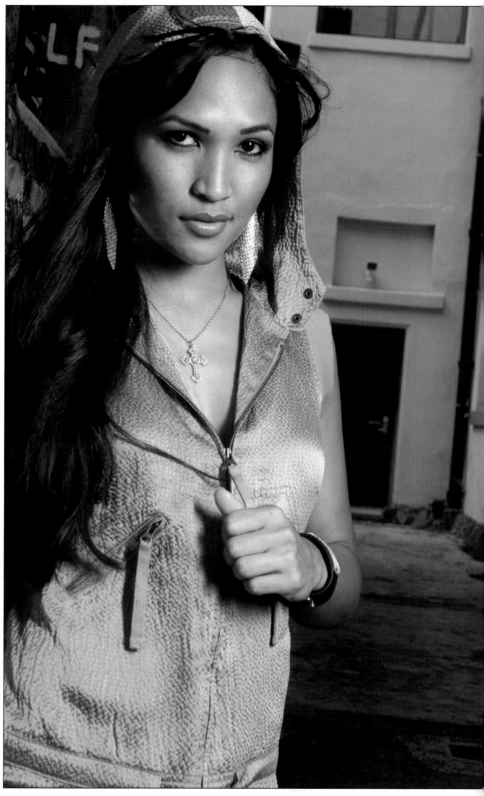

We took a small StripDome into a funky alley across the street from the studio to create a different fashion look for Tishanna Yabes's portfolio. The shutter speed was set at ¹⁄₅₀₀ of a second to keep the white wall and door down the alley from becoming too bright and distracting. The small StripDome became the main light in the relative shade of the alley. The image was exposed at f8⁹⁄₁₀ (f10) at ¹⁄₅₀₀ of a second.

This chapter started with a discussion about trying to use light modifiers to blend in with the surroundings when using strobes outdoors. My photography took a sudden turn and became much more creative when my friend Harry Lang was working with me. He was constantly asking "what if . . . ?" We end this creative journey by asking, "What if we took the opposite approach and brought a harsh light source into an area dominated by soft diffused light?"

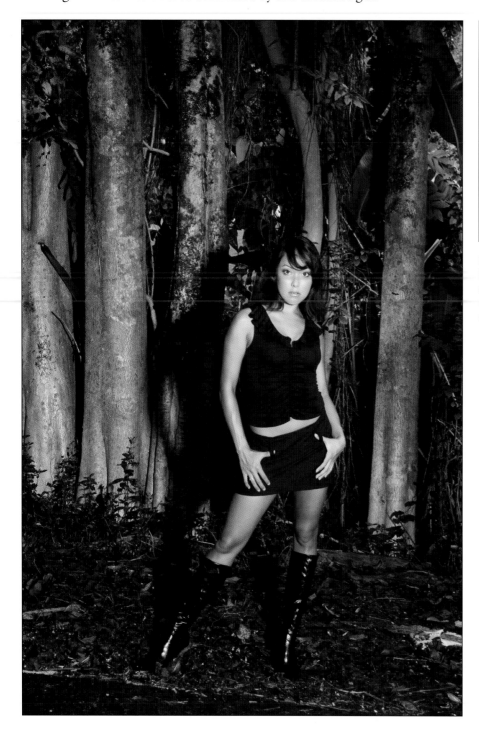

Learn the rules of lighting first, then creatively break then when necessary. Use your tools to create the image you want. Here Kathryn was lit with a direct spotlight to add the needed "pop" to create a high-fashion look on location.

INDEX

DYNAMIC WILDLIFE PHOTOGRAPHY

Cathy and Gordon Illg

Taking wildlife pictures that will impress today's savvy viewers requires a lot more than just a good exposure. Learn how to add drama and emotion to create "wow!" shots. $29.95 list, 8½x11, 128p, 150 color photos, index, order no. 1782.

THE MASTER GUIDE TO DIGITAL SLR CAMERAS

Stan Sholik and Ron Eggers

What makes a digital SLR the right one for you? What features are available? What should you look out for? These questions and more are answered in this helpful guide. $29.95 list, 8½x11, 128p, 180 color photos, index, order no. 1791.

DIGITAL INFRARED PHOTOGRAPHY

Patrick Rice

The dramatic look of infrared photography has long made it popular—but with digital it's actually *easy* too! Add digital IR to your repertoire with this comprehensive book. $29.95 list, 8½x11, 128p, 100 b&w and color photos, index, order no. 1792.

THE BEST OF DIGITAL WEDDING PHOTOGRAPHY

Bill Hurter

Explore the groundbreaking images and techniques that are shaping the future of wedding photography. Includes dazzling photos from over 35 top photographers. $29.95 list, 8½x11, 128p, 175 color photos, index, order no. 1793.

INTO YOUR DIGITAL DARKROOM STEP BY STEP

Peter Cope

Make the most of every image—digital or film— with these techniques for photographers. Learn to enhance color, add special effects, and much more. $29.95 list, 8½x11, 128p, 300 color images, index, order no. 1794.

PROFESSIONAL STRATEGIES AND TECHNIQUES FOR DIGITAL PHOTOGRAPHERS

Bob Coates

Learn how professionals—from portrait artists to commercial specialists—enhance their images with digital techniques. $29.95 list, 8½x11, 128p, 130 color photos, index, order no. 1772.

LIGHTING TECHNIQUES FOR
LOW KEY PORTRAIT PHOTOGRAPHY

Norman Phillips

Learn to create the dark tones and dramatic lighting that typify this classic portrait style. $29.95 list, 8½x11, 128p, 100 color photos, index, order no. 1773.

THE BEST OF WEDDING PHOTOJOURNALISM

Bill Hurter

Learn how top professionals capture these fleeting moments of laughter, tears, and romance. Features images from over twenty renowned wedding photographers. $34.95 list, 8½x11, 128p, 150 color photos, index, order no. 1774.

WEDDING AND PORTRAIT PHOTOGRAPHERS' LEGAL HANDBOOK

N. Phillips and C. Nudo, Esq.

Don't leave yourself exposed! Sample forms and practical discussions help you protect yourself and your business. $29.95 list, 8½x11, 128p, 25 sample forms, index, order no. 1796.

PROFITABLE PORTRAITS

THE PHOTOGRAPHER'S GUIDE TO CREATING PORTRAITS THAT SELL

Jeff Smith

Learn how to design images that are precisely tailored to your clients' tastes—portraits that will practically sell themselves! $29.95 list, 8½x11, 128p, 100 color photos, index, order no. 1797.

PROFESSIONAL TECHNIQUES FOR
BLACK & WHITE DIGITAL PHOTOGRAPHY

Patrick Rice

Digital makes it easier than ever to create black & white images. With these techniques, you'll learn to achieve dazzling results! $29.95 list, 8½x11, 128p, 100 color photos, index, order no. 1798.

THE BEST OF PHOTOGRAPHIC LIGHTING

Bill Hurter

Top professionals reveal the secrets behind their successful strategies for studio, location, and outdoor lighting. Packed with tips for portraits, still lifes, and more. $34.95 list, 8½x11, 128p, 150 color photos, index, order no. 1808.

MARKETING & SELLING TECHNIQUES

FOR DIGITAL PORTRAIT PHOTOGRAPHY

Kathleen Hawkins

Great portraits aren't enough to ensure the success of your business! Learn how to attract clients and boost your sales. $34.95 list, 8½x11, 128p, 150 color photos, index, order no. 1804.

ARTISTIC TECHNIQUES WITH ADOBE® PHOTOSHOP® AND COREL® PAINTER®

Deborah Lynn Ferro

Flex your creative skills and learn how to transform photographs into fine-art masterpieces. Step-by-step techniques make it easy! $34.95 list, 8½x11, 128p, 200 color images, index, order no. 1806.

DIGITAL PHOTOGRAPHY BOOT CAMP

Kevin Kubota

Kevin Kubota's popular workshop is now a book! A down-and-dirty, step-by-step course in building a professional photography workflow and creating digital images that sell! $34.95 list, 8½x11, 128p, 250 color images, index, order no. 1809.

PROFESSIONAL POSING TECHNIQUES FOR WEDDING AND

PORTRAIT PHOTOGRAPHERS

Norman Phillips

Master all of the techniques you need to pose subjects successfully—whether you are working with men, women, children, or groups. $34.95 list, 8½x11, 128p, 260 color photos, index, order no. 1810.

THE BEST OF FAMILY PORTRAIT PHOTOGRAPHY

Bill Hurter

Acclaimed photographers reveal the secrets behind their most successful family portraits. Packed with award-winning images and helpful techniques. $34.95 list, 8½x11, 128p, 150 color photos, index, order no. 1812.

BLACK & WHITE PHOTOGRAPHY

TECHNIQUES WITH ADOBE® PHOTOSHOP®

Maurice Hamilton

Become a master of the black & white digital darkroom! Covers all the skills required to perfect your black & white images and produce dazzling fine-art prints. $34.95 list, 8½x11, 128p, 150 color/b&w images, index, order no. 1813.

PROFESSIONAL MARKETING & SELLING TECHNIQUES

FOR DIGITAL WEDDING PHOTOGRAPHERS, SECOND EDITION

Jeff Hawkins and Kathleen Hawkins

Taking great photos isn't enough to ensure success! Become a master marketer and salesperson with these easy techniques. $34.95 list, 8½x11, 128p, 150 color photos, index, order no. 1815.

MASTER COMPOSITION

GUIDE FOR DIGITAL PHOTOGRAPHERS

Ernst Wildi

Composition can make or break an image. In this book, Ernst Wildi shows you how to analyze your scene or subject to produce your very best images. $34.95 list, 8½x11, 128p, 150 color photos, index, order no. 1817.

THE BEST OF ADOBE® PHOTOSHOP®

Bill Hurter

Rangefinder editor Bill Hurter calls on the industry's top photographers to share their strategies for using Photoshop to intensify and sculpt their images. $34.95 list, 8½x11, 128p, 170 color photos, 10 screen shots, index, order no. 1818.

HOW TO CREATE A HIGH PROFIT PHOTOGRAPHY BUSINESS

IN ANY MARKET

James Williams

Learn to identify your ideal client type, create the images they want, and watch your financial and artistic dreams spring to life—no matter your location! $34.95 list, 8½x11, 128p, 200 color photos, index, order no. 1819.

BEGINNER'S GUIDE TO ADOBE® PHOTOSHOP®, 3rd Ed.

Michelle Perkins

Enhance your photos, create original artwork, or add unique effects to any image. Topics are presented in short, easy-to-digest sections. $34.95 list, 8½x11, 128p, 80 color images, 120 screen shots, order no. 1823.

THE BEST OF PROFESSIONAL DIGITAL PHOTOGRAPHY

Bill Hurter

Digital imaging has a stronghold on the photographic industry. This book spotlights the methods that world-renowned photographers use to create their standout images. $34.95 list, 8½x11, 128p, 180 color photos, 20 screen shots, index, order no. 1824.

PROFESSIONAL PORTRAIT LIGHTING

TECHNIQUES AND IMAGES FROM MASTER PHOTOGRAPHERS

Michelle Perkins

Get a behind-the-scenes look at the lighting techniques employed by the world's top portrait photographers. $34.95 list, 8½x11, 128p, 200 color photos, index, order no. 2000.

MASTER POSING GUIDE

FOR CHILDREN'S PORTRAIT PHOTOGRAPHY

Norman Phillips

Create perfect portraits of infants, tots, kids, and teens. Includes techniques for standing, sitting, and floor poses for boys and girls, individuals, and groups. $34.95 list, 8½x11, 128p, 305 color images, order no. 1826.

WEDDING PHOTOGRAPHER'S HANDBOOK

Bill Hurter

Learn to produce images with unprecedented technical proficiency and superb, unbridled artistry. Includes images and insights from top industry pros. $34.95 list, 8½x11, 128p, 180 color photos, 10 screen shots, index, order no. 1827.

RANGEFINDER'S PROFESSIONAL PHOTOGRAPHY

edited by Bill Hurter

Editor Bill Hurter shares over one hundred "recipes" from *Rangefinder's* popular cookbook series, showing you how to shoot, pose, light, and edit fabulous images. $34.95 list, 8½x11, 128p, 150 color photos, index, order no. 1828.

LEGAL HANDBOOK FOR PHOTOGRAPHERS, 2nd Ed.

Bert P. Krages, Esq.

Learn what you can and cannot photograph, how to handle conflicts should they arise, how to protect your rights to your images in the digital age, and more. $34.95 list, 8½x11, 128p, 80 b&w photos, index, order no. 1829.

PROFESSIONAL FILTER TECHNIQUES

FOR DIGITAL PHOTOGRAPHERS

Stan Sholik

Select the best filter options for your photographic style and discover how their use will affect your images. $34.95 list, 8½x11, 128p, 150 color images, index, order no. 1831.

MASTER'S GUIDE TO WEDDING PHOTOGRAPHY

CAPTURING UNFORGETTABLE MOMENTS AND LASTING IMPRESSIONS

Marcus Bell

Learn to capture the unique energy and mood of each wedding and build a lifelong client relationship. $34.95 list, 8½x11, 128p, 200 color photos, index, order no. 1832.

MASTER LIGHTING GUIDE

FOR COMMERCIAL PHOTOGRAPHERS

Robert Morrissey

Learn to use the tools and techniques the pros rely upon to land corporate clients. Includes diagrams, images, and techniques for a failsafe approach to creating shots that sell. $34.95 list, 8½x11, 128p, 110 color photos, 125 diagrams, index, order no. 1833.

DIGITAL CAPTURE AND WORKFLOW

FOR PROFESSIONAL PHOTOGRAPHERS

Tom Lee

Cut your image-processing time by fine-tuning your workflow. Includes tips for working with Photoshop and Adobe Bridge, plus framing, matting, and more. $34.95 list, 8½x11, 128p, 150 color images, index, order no. 1835.